DRAW
Like the
MASTERS

BARRON'S

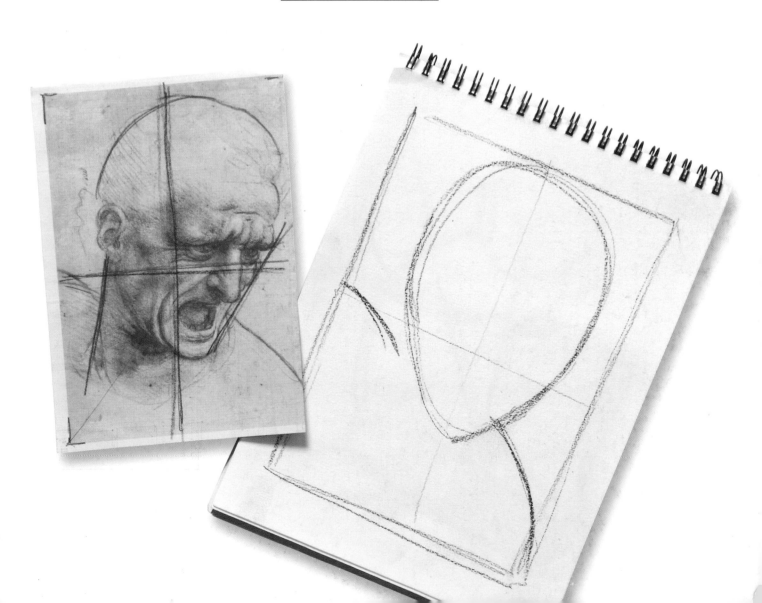

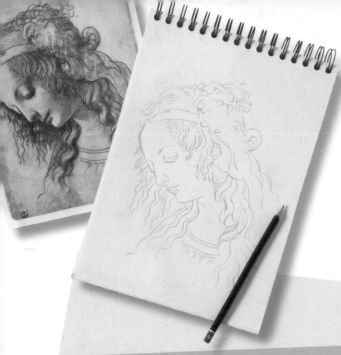

How to access
the interactive content

You can access the content by registering on the web page or through augmented reality:

THROUGH THE WEB PAGE

Register on the web page for free at
www.books2AR.com/dgm
entering the following code:

DGM474D2L8PM

Three simple steps

1

Scratch off the rectangle

2

Go to the site and enter the code

3

Sign up

USING AUGMENTED REALITY

1. Download the free AR app for IOS at **http://www.books2AR.com/dgmIOS** or for Android at **http://www.books2AR.com/dgmAndroid**

or here:

QR for IOS

QR for Android

Available on the **App Store**

ANDROID APP ON **Google play**

2. Use the app to scan the page where you see one of these three icons:

Print. Here you can print the original work of art through an email message.

Video. Shows a specific process or technique in detail.

Observe. This lets you see other works by the same artist.

3. Discover the content.

Augmented reality in three simple steps:

1 Download the app for free.

2 Scan the icon that appears on the page.

3 Discover the interactive content.

The app requires an Internet connection to access the interactive content.

Print

Observe

Video

Augmented Reality

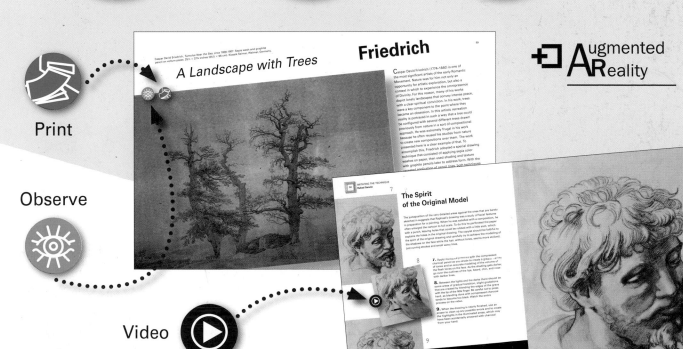

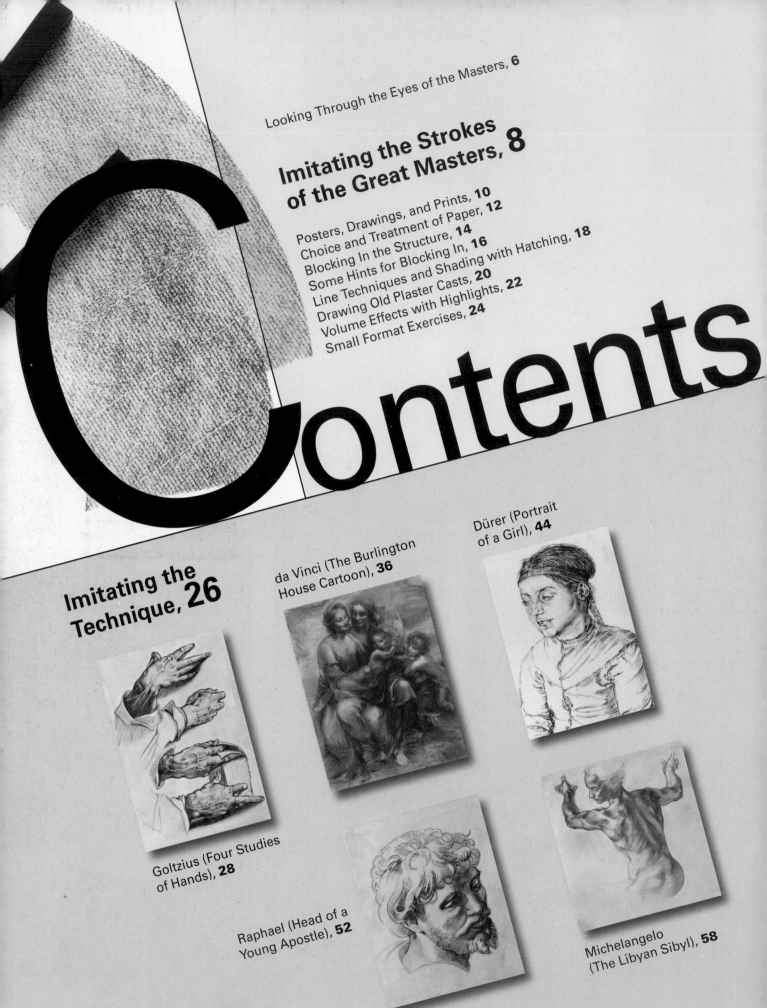

Looking Through the Eyes of the Masters, **6**

Imitating the Strokes of the Great Masters, **8**

Posters, Drawings, and Prints, **10**
Choice and Treatment of Paper, **12**
Blocking In the Structure, **14**
Some Hints for Blocking In, **16**
Line Techniques and Shading with Hatching, **18**
Drawing Old Plaster Casts, **20**
Volume Effects with Highlights, **22**
Small Format Exercises, **24**

Contents

Imitating the Technique, **26**

Goltzius (Four Studies of Hands), **28**

da Vinci (The Burlington House Cartoon), **36**

Dürer (Portrait of a Girl), **44**

Raphael (Head of a Young Apostle), **52**

Michelangelo (The Libyan Sibyl), **58**

Rubens (Study
for a Lion), **66**

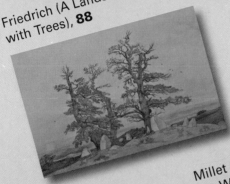

Rembrandt (Portrait of a
Bearded Old Man), **74**

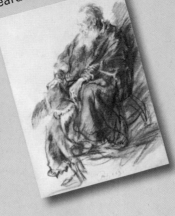

Fragonard (A Garden
with Buildings), **80**

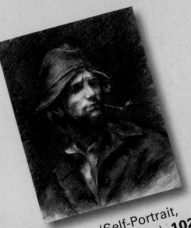

Rossetti (A Portrait), **96**

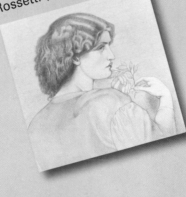

Friedrich (A Landscape
with Trees), **88**

Courbet (Self-Portrait,
Man with the Pipe), **102**

Millet (The Cat at
the Window), **118**

van Gogh
(La Guinguette), **126**

Ruskin (A Street
in Abbeville), **110**

A Good Work of Art
Finished 134

Improving the Work with Washes, **136**
Highlights on Toned Backgrounds, **138**
Personality in the Copy, **140**
Matting and Framing, **142**

Looking Through
the Eyes of the Masters

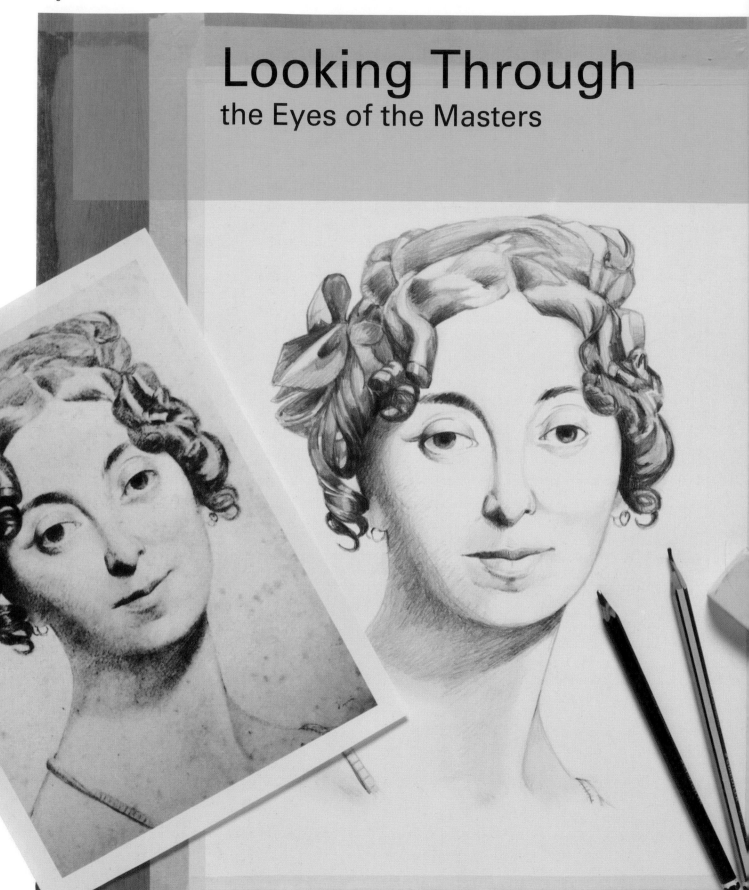

Copying the drawings of the great masters from throughout history has been a common practice for many years, and it is one of the most popular techniques among art school students in understanding the works of the great painters and sculptors of the past.

The practice of copying works of art became popular in the Renaissance, specifically during the 16th century, when the nobility and moneyed bourgeoisie began collecting art, and a strong market for reproductions of the most admired painting of the time began to grow.

Although they are less appreciated than paintings and sculptures, drawings have always been the basis for understanding any artistic discipline, a field for trials, a space for experimentation, innovation, practicing techniques, and improving your abilities. In other words, a way of learning and adapting the approaches of artists like Michelangelo, Leonardo da Vinci, Raphael, Dürer, Caravaggio, Rubens, and Rembrandt, among many others. Copying old drawings and prints helped students develop a skilled hand, learn the styles, calculate proportions, practice shading, or simply attempt to understand each artist's particular vision of reality. Thus, the main goal of copying is not duplicating, but recreating, and assimilating a specific technique or way of interpreting the model, with the hope that understanding the visual acuity and the abilities of a great master can help the student develop a personal visual language and style. To express it in other words, copying reveals the expertise of the master's technique, and it has the bold goal of equaling the skill of the masters of the past.

Reproducing drawings, paintings, and sculpture by the great masters has been a common practice for hundreds of years. The proof of this are the many beautiful testimonials that are found in the world's greatest art museums today. It is worth pointing out that the great room at the Victoria and Albert Museum in London, the Weston Cast Courts, has some of the most important reproductions of sculptures of the Italian Renaissance. For those of you who wish to see them to study and draw models, they are very accurate reproductions of the originals.

It may be surprising for those of you who thought this was an outdated practice, but this kind of drawing has been part of the formation and apprenticeship of the most important fine artists of the 20th century, such as Cezanne, Van Gogh, Seurat, Picasso, Matisse, and Giacometti, among many other lesser-known figures.

The great Italian artist Giorgio de Chirico, in his study *Il return al mestiere*, explains that "you must begin by copying figures reproduced in prints, then later move on to copying statues." And he adds that "it takes four or five years before you can attempt copying directly from nature." Copying drawings by well-known artists with dry media, as we suggest in this book, can be an extraordinarily beneficial exercise; and yes, it requires patience, a lot of reflection, a certain amount of skill, and a great knowledge of technique.

The sculptor Gian Lorenzo Bernini affirmed that copying the drawings of the great masters is very useful in the education of an artist. Practicing with older subjects and styles allows you to develop a sense of beauty, giving you a very valuable base that will serve you when you are faced with models in real life.

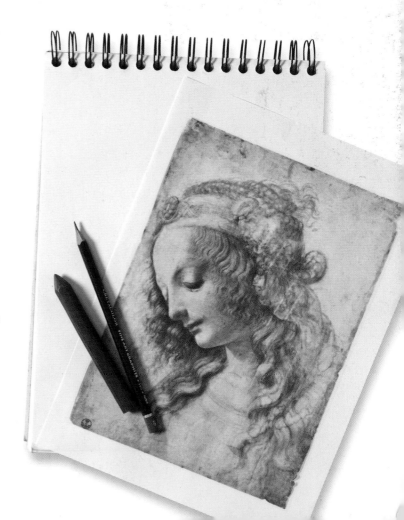

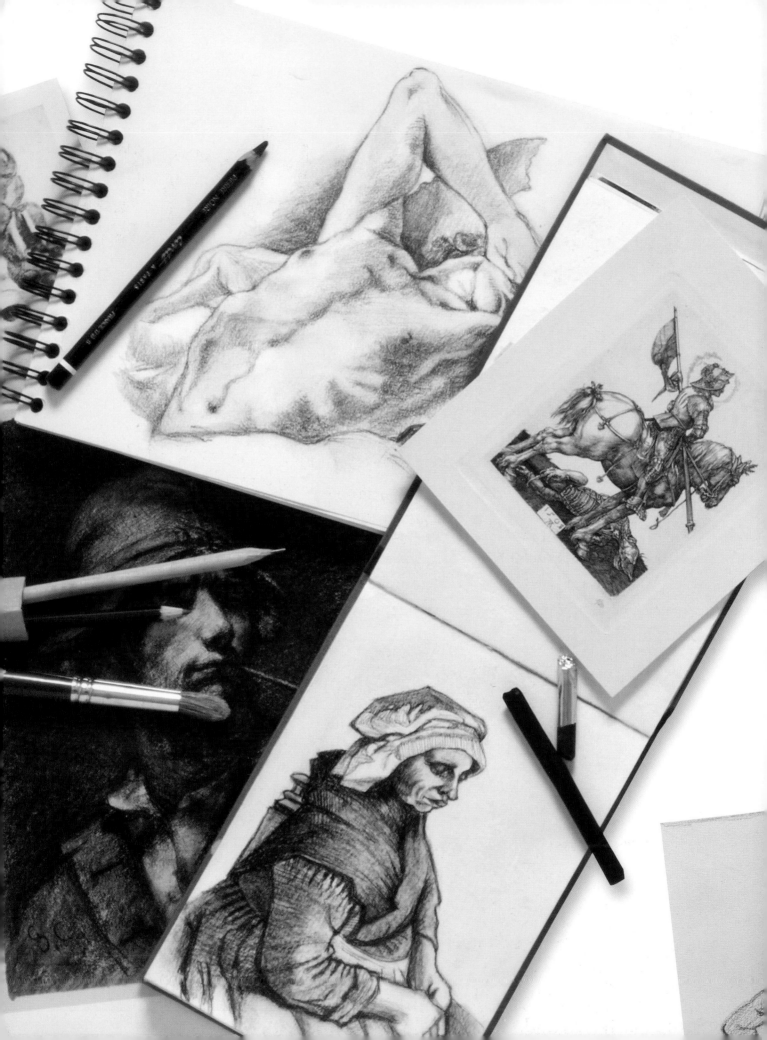

Imitating
the Strokes of the Great Masters

In this first section, we offer detailed information for learning how to copy the drawings of the great masters with dry media, those which are used by rubbing (friction) like charcoal, graphite, chalk, sanguine crayon and their derivatives. It will help you understand the actual structure of graphic thought using these materials: how to block in the model, which method to use, how to use the materials to extract lessons that the artist can use to project his or her own experience, etc. Here we offer some guidelines and useful advice so the artist can better construct and organize his or her work, not only to ensure the most faithful reproduction possible but also to make it easier to recreate the style and the artistic techniques used by each artist.

Posters,
Drawings, and Prints

During the Renaissance, painting studios frequently began using drawings and prints in the same manner. The drawings were used as preparatory studies to decide on the final composition of the work, or on particular aspects like the shapes and positioning of hands, the expression on a face, or the folds in drapery. Copying is a first-rate method for "learning to see" because it forces you to see through someone else's eyes and focus on the way that person saw something and then put it on a piece of paper. It is an effective apprenticeship system, demonstrated by the excellent quality of the copies that have been made by extraordinary artists.

Models for Copying

Initially, art students used to learn from drawings and studies made by the master of the studio, who they assisted, or with a collection of prints that were used with the express intention of practicing artistic talents, how to use drawing materials, and a better understanding of the most complex parts of the model, usually the human figure. Thanks to the prints, artists had a great number of models to choose from. Their popularity and wide distribution without a doubt contributed to the appearance of the Academies. Prints were so widely accepted that it became rare to use live models when working, opting instead to compose paintings based on the images represented in the prints.

Engraved images were the main source of inspiration for artists for centuries. The illustrated prints were used for copying poses, compositions, and people.

The artists of the past rarely drew from nature; instead they composed their works by copying prints that were circulated throughout Europe. Here is an example of how a 16th-century artist based his painting on a print by Aecidium Saddler and Augustine Carraci.

Choosing Quality Models

Nowadays, it is much easier for fans of drawing to copy because there are so many high-resolution reproductions available, of which the artist can easily adjust the colors and distinguish the details of the lines. Before starting, however, you should select your models very carefully and obtain a reproduction on paper that is at least 8½ × 11". There is also the possibility of using a model on your tablet or computer screen. It is a good idea to choose subjects done by different masters, with different personalities, to get a wide variety of graphic interpretations and to make the copying exercise fun and interesting.

Catalogs from drawing exhibitions are a good source of inspiration when looking for models to draw.

It is a good idea to work with high-resolution reproductions so you can easily see the fine lines and shading. Be sure you have several different models to work from.

Ford Madox Brown, Preparatory study for The Last of England, 1852. Pencil drawing on card, 16 × 14³⁄₈ inches (40.8 × 36.5 cm). Birmingham Museum and Art Gallery (Birmingham, UK)

THE DRAWING AS A PROJECT

Drawing is an artistic discipline in itself, as important as painting and sculpture, but in the past it wasn't always that way. Until well into the 20th century, it was considered to be a simple process, a preliminary step to creating some kind of larger scale work of art, a medium for experimenting and a support for practicing details and working out compositions. Many of the following works allow you to compare the preliminary drawing with the artist's final work of art.

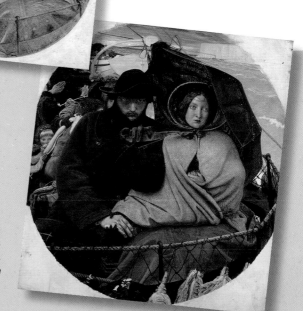

Ford Madox Brown, The Last of England, 1855. Oil on canvas, 18¹⁄₄ × 16⁵⁄₈ inches (46.4 × 42.3 cm). Fitzwilliam Museum, Cambridge, United Kingdom

Choice and Treatment
of Paper

It is helpful to have a portfolio full of paper of different colors, weights, and textures so you can choose the most appropriate one for each case, one that most resembles the work that you are going to copy.

Before you begin to copy a drawing, you must carefully choose the most appropriate support, one that will work well with the medium you are using and can handle the effects and finish that you plan to give the drawing. You should have a portfolio with papers of different colors, types, and textures so you can choose one that is closest to the one used in the original drawing. Sometimes the tone and texture are not exactly the same, but this should not be a problem since there are methods for modifying the background color and for matching the final colors to those in the original photo.

A properly prepared support will increase the probability of success in each drawing.

Toning the Paper

Sometimes the tone of the paper does not correspond to that of the model, either because the paper has aged or because in the beginning the artist applied a patina with a color wash. In such cases, you can tint the paper with watercolors to match, as best as you can, to the color of the original. A simple wash will soften the impact of the white paper and will give it a raw, or even aged, look.

After it has dried, you can draw over it normally. Do not be tempted to imitate the oxidized streaks on the paper, tears, or water damage, since this is not the point of copying. You are making a copy, not a forgery. It will be enough to adjust the background with a wash or wipe the surface with some pigment and a cotton rag.

You can also make a small pad of paper or cotton. Scrape a stick of chalk, dab the powder with the pad and wipe the pigment across the surface of the support.

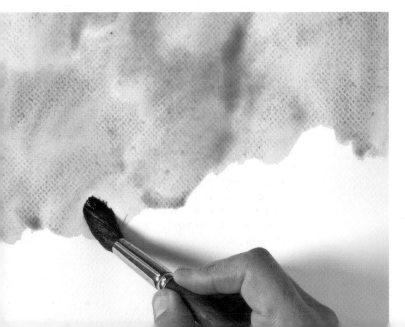

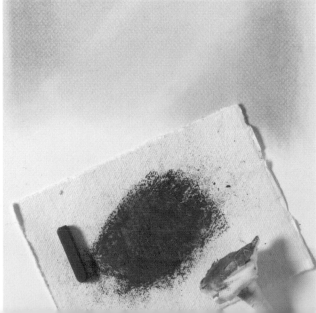

Framing to Protect the Paper

Many copyists make use of the grid, guide lines, or squares that are drawn on the support that allow the artist to compare lines with each drawing, calculate distances, and adjust proportions. While this method is very useful in painting because the grid ends up hidden under layers of paint, it is not at all recommended for drawings; it usually cannot be completely erased and therefore could ruin the drawing. There is an alternative method that consists of placing strips of paper over both the photographic reproduction and the support to create quadrants that will frame the drawing. This system helps you to avoid damaging the paper and filling it with unnecessary lines and marks.

The use of a grid is very effective for copying a drawing that will be used for a painting, but it is not effective when copying drawings, because no matter how hard you erase, the lines will not completely disappear.

Cut some strips of paper and tape them to the support. The strips create measures and quadrants that will make it easier to frame the drawing without having to draw any grid lines.

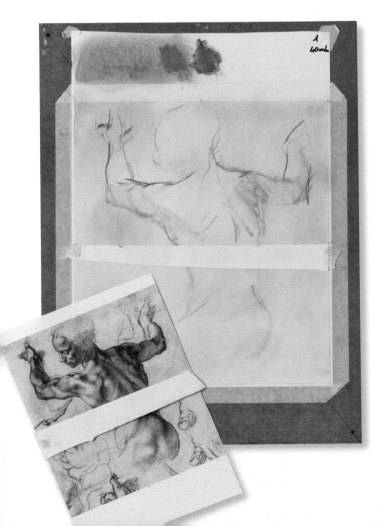

To frame the drawing, you can place the photographic reproduction under a piece of acetate and draw compositional guidelines with a permanent marker. This will help you analyze the placement of the model on the paper.

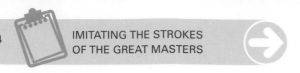

Blocking In
the Structure

Study of a male torso from behind, by Peter Paul Rubens (1577–1640).

The techniques of sketching, composing, and framing are always done at the start of a drawing, since what you see can be put in order and a hierarchy created. For a long time, the drawing and painting manuals have explained the precise construction of the physical nature of the drawing, based on geometries that help make studying the model easier and that place it on the paper so that each one of its parts is in correct proportion with the others.

Securing the Structure

The success of any drawing is determined by its structure and foundation. If the proportions are correct, that is, matching reality as much as possible, the work of defining and modeling is much easier. For this reason we recommend dedicating a large amount of your attention and time to blocking in the model, making the necessary corrections, and not worrying about the outlines or shading until you are completely sure that the structure is sound. A slight error can look much bigger when the drawing is finished.

Here is a schematic explanation of blocking in a plaster figure based on finding the axes, and comparing measurements and the vertical relationships between points.

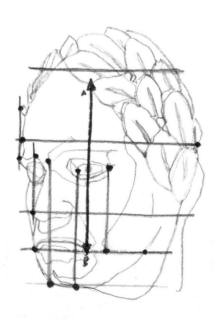

Sketch of geometric lines used to block in the drawing by Rubens.

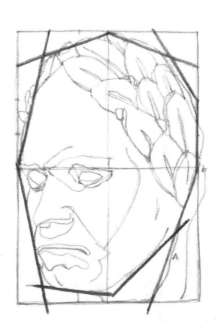

Framework Based on Segments

There are different ways of blocking in a drawing. Without a doubt, the most popular and often used is blocking in the masses of a figure with polygonal lines, which means breaking the model up into straight lines that form a framework where we see the inclination of each segment and angle. This initial sketch should be made with light strokes so they can be easily erased once the definitive outline of the form has been determined. Another method is defining the figure by aligning points and blocking in with shading by lightly applying charcoal with the side of the stick.

I

1. To block in using segments, construct the framework with short lines that follow the outline of the figure.

2

2. Do some erasing and replace the initial geometric sketch with a finer, curved line that more closely follows the anatomy of the human figure.

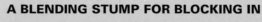

3

3. After you have created a solid and accurate line drawing, you can begin shading it with three different colors of chalk.

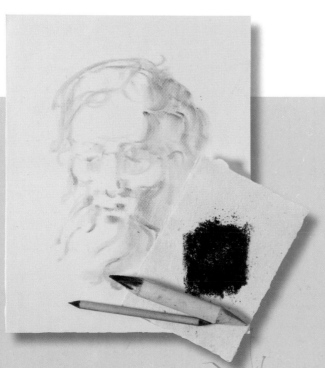

A BLENDING STUMP FOR BLOCKING IN

You can also block in a drawing with the tip of a blending stump (or tortillon). The line it makes is so light that it is easily integrated into the work without having to do any erasing; it is unlikely to tear the paper, and it works very well for drawings that have rich gradations of shadow. On the other hand, you should not use it when making a line drawing that doesn't require much shading.

Some Hints for
Blocking In

Experienced artists are quite good at blocking in the model free hand without many mistakes. However, beginning artists can be challenged by this task. In the following section, we offer some hints, or "small tricks," so that the challenges won't stop you from making good quality copies.

The Light Table

Any beginning artist can make an improvised projector by placing a strong light underneath a glass or plastic tabletop used as a drawing surface. Putting a piece of drawing paper over a photocopy and turning on the light will make both papers translucent and allow you to make out the main shapes of the copy underneath. Use charcoal or a graphite pencil to carefully trace the shapes of the model to create a well-proportioned line sketch. The line should be light because you may want to erase some of the lines in later phases of the work.

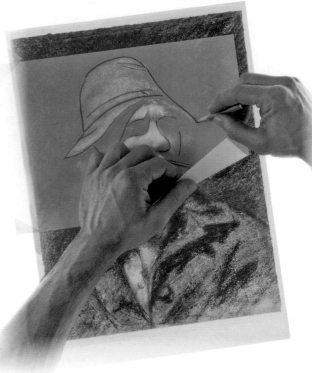

A light table makes it easy to trace the model. Just put your drawing paper over the photocopy and project the model.

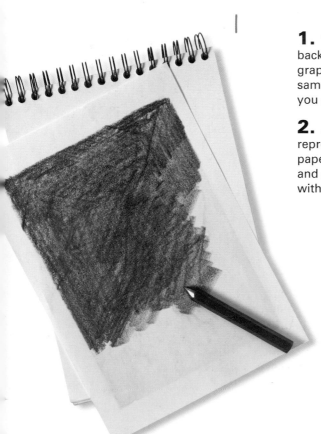

1. To trace, cover the back of the photocopy with graphite. It should be the same size as the support you are going to use.

2. Attach the reproduction over the paper with masking tape and go over the outlines with a dull pencil.

2

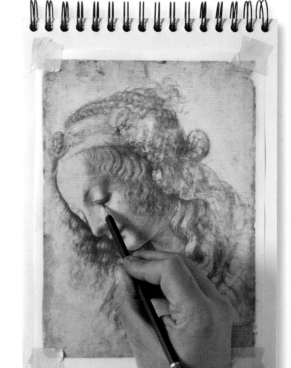

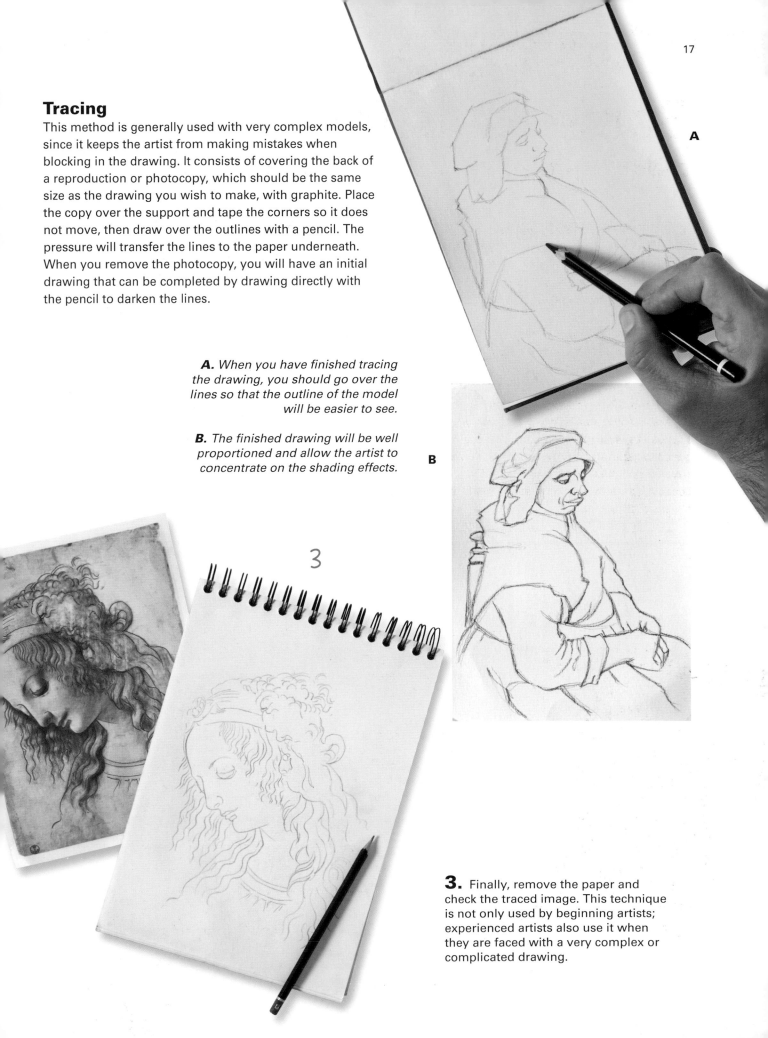

Tracing

This method is generally used with very complex models, since it keeps the artist from making mistakes when blocking in the drawing. It consists of covering the back of a reproduction or photocopy, which should be the same size as the drawing you wish to make, with graphite. Place the copy over the support and tape the corners so it does not move, then draw over the outlines with a pencil. The pressure will transfer the lines to the paper underneath. When you remove the photocopy, you will have an initial drawing that can be completed by drawing directly with the pencil to darken the lines.

A. When you have finished tracing the drawing, you should go over the lines so that the outline of the model will be easier to see.

B. The finished drawing will be well proportioned and allow the artist to concentrate on the shading effects.

A

B

3. Finally, remove the paper and check the traced image. This technique is not only used by beginning artists; experienced artists also use it when they are faced with a very complex or complicated drawing.

Line Techniques
and Shading with Hatching

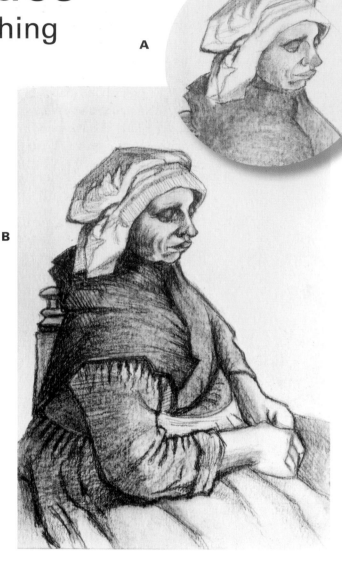

A

B

In traditional representational drawings, the shading is normally done after blocking in and completing the structure using lines. It is never direct; it is usually applied gradually by progressively darkening the values, which allows you to have more control over the final results.

Pencil Lines: Hatching and Building Up

When using pencils, whether graphite, chalk, or charcoal, it is easier to draw lines than to create shading. However, when you are copying, you can build up light lines by drawing over them or by cross hatching, which should allow you to display the tonal effects of the model. Just keep one basic premise in mind: the direction of every line creates the particular texture of each surface and helps to contrast and differentiate the planes.

A. The initial shading with charcoal is done with a vine charcoal stick. Apply it very lightly as you blend it with your fingertips.

B. Stronger contrasts are better created with compressed charcoal—it makes deeper blacks and gives you more control over the lines.

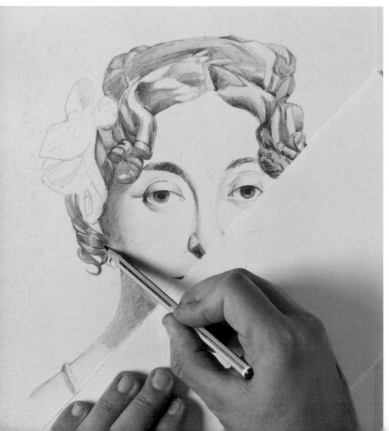

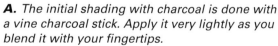

The shading effects on old drawings were made very lightly and gradually. Protect your drawing with a piece of paper to avoid smearing the work with your hand.

Working Slowly and Progressively with Charcoal

When using charcoal to make a copy, it is best to begin shading very lightly, always working from light to dark. The sticks should be long and held at the very end; this way you can make sure the shading will be very light. The final value is created by going over the area numerous times while applying pressure to the stick. Shading the copy like this can be adjusted in a controlled manner, and you won't have to worry about erasing or reducing the shading because you pressed too hard on the paper.

This is a copy of an 18th century drawing, made with a sanguine pencil using different variations of crosshatching.

 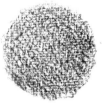

A **B** **C** **D**

Here are some of the more common kinds of shading done with a graphite pencil: parallel lines (A), crosshatching at a 30° angle (B), gray or even shading (C), and scrolling or scribbled lines (D).

HOW TO SHARPEN PENCILS AND STICKS

When making copies, especially those that require very delicate work, you should never draw with the square end of chalk or with a pencil point made from a pencil sharpener. Chalk, compressed charcoal, and pencils should always be sharpened with a craft knife. This will ensure a line that is light, controlled, precise, and it will avoid tearing the paper.

Drawing
Old Plaster Casts

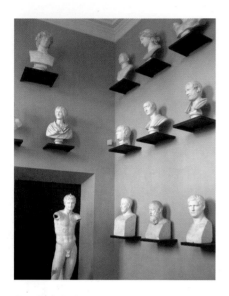

Reproductions of ancient sculptures have commonly been used in the training of the great masters, and they continue to be a practical resource in the teaching of academic drawing. Copying these plaster figures gives you access to models of ideal beauty that are well-balanced and have clear shapes and forms. Plaster molds have become valuable tools for learning about the human figure, proportions, facial features, and expressions.

Replicas of plaster casts by students of the French Academy in Rome.

A Step-by-Step Process of Apprenticeship
In the 18th and 19th centuries when students in the art academies had mastered the fundamentals of blocking in geometric shapes, they went on to draw plaster casts. These exercises were usually done with graphite, charcoal, or chalk, and the goal was to copy classic sculptures. Once the student was able to reproduce plaster casts successfully, he or she was ready to face the challenge of making monochrome drawings of the live human figure. The monochrome approach avoided the challenges of color, which were left for a more advanced phase.

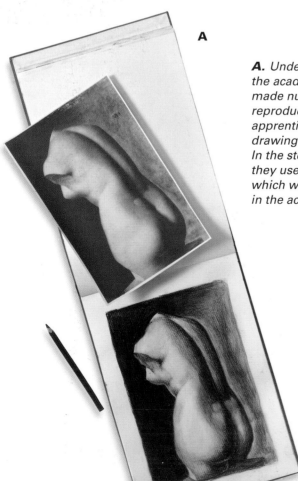

A

A. Under the direction of the academy, apprentices made numerous copies of reproductions during their apprenticeship, in which drawing was fundamental. In the step-by-step process, they used plaster models, which was very common in the academies.

B

B. The outlines of the shadows are drawn heavy with charcoal, indicating the shapes of the shadows while taking care to maintain the proportions.

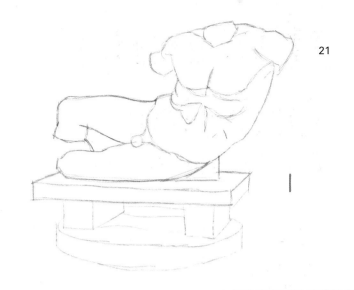

I

Copying the Copy

Plaster figures presented in an adequate light source, well studied and controlled, allow art students to practice interesting contrasts and gradations of light, which they can change according to their intentions and expressive requirements. Many artists, among them Picasso and Cezanne, used this method to study forms and modeling. The copyist can practice directly from plaster casts or even try to reproduce drawings of plaster casts made by the great artists of the past during their student years. It is a good way to learn some shading techniques and to master the progressive passage of light to shadow. Here we will practice with a study that Pablo Picasso did during his years of apprenticeship.

2

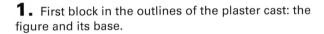

1. First block in the outlines of the plaster cast: the figure and its base.

2. With the shape and proportions established, start working on the shading by applying grays and gradations. If you hold your pencil at the end, the shading will be subtle with little contrast.

3. The development of the modeling is important for creating the volume effects on the torso, while the background shadows will help highlight the outline as well as the pure white color of the plaster cast.

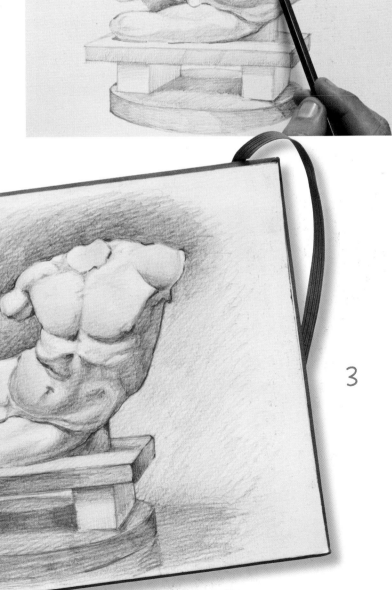

3

Volume Effects
with Highlights

A

A. The modeling effects are created by applying shading very lightly and blending with your fingertips.

Shading is one technique that all copyists should master, but one that usually takes the most time during the apprenticeship stages. This is because the placement of the shadows is not arbitrary; instead it is subject to rules that determine their placement, shape, size, and density. Also, the interpretation of the artist must be included here, which, in many cases, will become a distinctive characteristic of his/her style.

Practicing Modeling

Modeling consists of representing the surfaces by shading them with gradual transitions of light to shadow, without the presence of strokes and lines, but only areas of gradation without any stark contrasts. The best way to do this is by dragging the side of a stick of charcoal or chalk across the support. This will allow you to work on a large area as well as develop the gradations much easier while avoiding any trace of lines. Then you can smooth them with your fingertips to create a blended effect. If you have done it properly, you will have successfully created shapes and surfaces that look like the model with all its volume and relief.

B

B. Incorporating additional values allows you to develop the gradations that create the effect of volume on the sphere.

C. The final effect of the relief ends when adding highlights with white chalk. The contrasts between the areas of light and shadow emphasize the spherical nature of the shape.

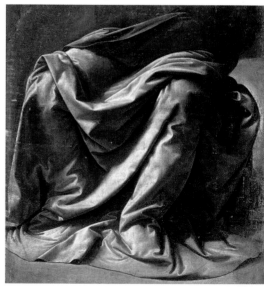

This simple shading exercise, a drapery study by Leonardo da Vinci, is a good starting point for practicing the effects of modeling and highlighting with white chalk.

C

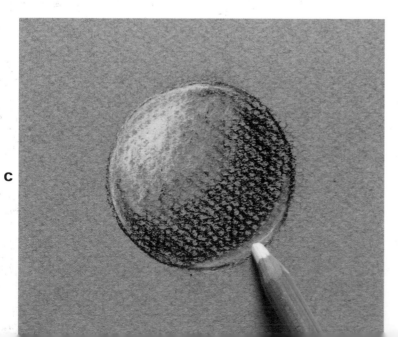

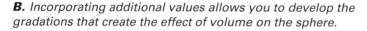

White Highlights

Some artists of the past worked on toned paper so that they could incorporate white highlights to the finished work. They began by shading the model in the traditional way with charcoal or chalk, blending, gradating, and modeling the shadows by hand, or maybe a blending stump if the representation was very small. Nowadays, when the model is completely shaded, the pigment is sprayed with a fixative before the final steps begin, which consist of adding highlights with white chalk. These highlights should be applied lightly, in very specific areas, and they create an almost magical effect, emphasizing the volumes in the drawing as if they were in relief and jumping right off the paper.

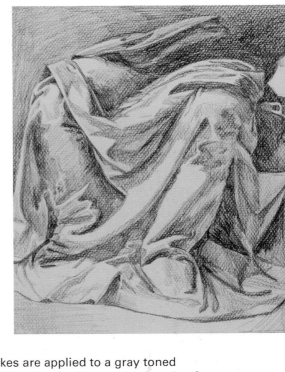

1

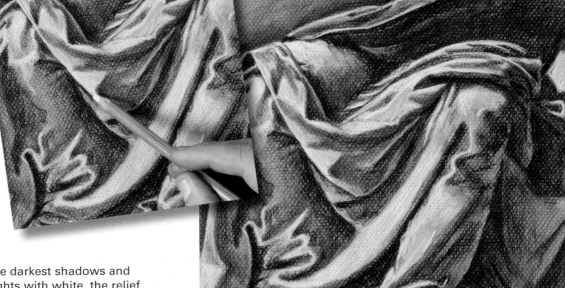

2

1. The first strokes are applied to a gray toned paper, barely marking the shadows with a couple of gray values. Leave a clear edge by not covering the lightest areas.

2. The modeling effect is created with the tip of a blending stump, rubbing the edges of the shading so they look lighter and gradated.

4

3. The white chalk highlights should only be applied on the highest parts of the drapery, where the impact of the light is strongest.

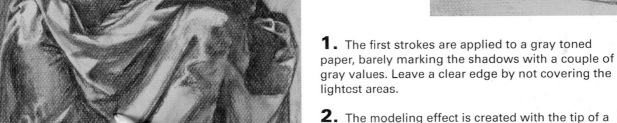

3

4. After reinforcing the darkest shadows and emphasizing the highlights with white, the relief effect of the drapery will look quite pronounced.

Small Format
Exercises

Before starting on the exercises that are in this book, it is a good idea to first make a few notes, sketches, or shading. We are talking about choosing a few simple models to practice lines and shading with graphite, charcoal, or chalk pencils. It is best to begin with small formats because the drawing (proportions and overall look) will be easier to control.

Compositional Schemes

If there is no way to do a tracing and you have to draw directly from the model, it helps to lay out the composition based on geometric shapes. You must simplify each element in a sketch that is a precise geometric shape. This approach will give you absolute control over the placement of the shapes, the proportions, the balance of the surrounding empty spaces, and it also helps you to adjust the angles of the main lines that define the outlines of the bodies. Once you have resolved the basic geometric sketch, you will be able to draw the model more accurately.

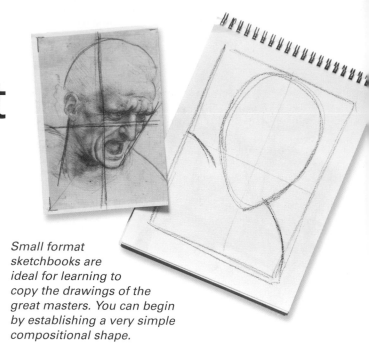

Small format sketchbooks are ideal for learning to copy the drawings of the great masters. You can begin by establishing a very simple compositional shape.

The Sketchbook

To draw well you must practice, and the best way to practice is to draw informally without the pressure to create a finished and detailed work of art. To start, select some images of simple drawings that can be finished somewhat quickly, and copy them in a small or medium format sketchbook. Block them in freehand, with very light lines, and place each part of the model carefully, keeping them in proportion to each other. Add the shading, then go over the lines to achieve the closest likeness possible. When working in a sketchbook, you should forget about chalk and charcoal sticks—it is better to use pencils. The drawing tool that you use should always be in accordance with the size of the support.

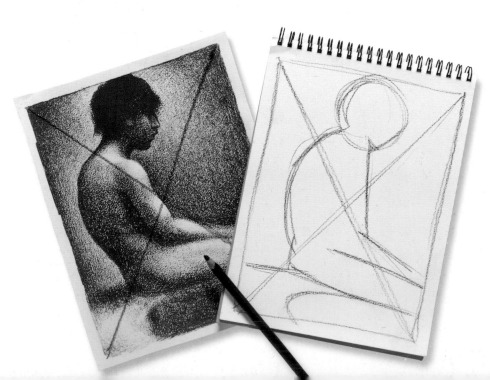

The compositional sketch is the most basic layout and represents a simplification of the shapes and spaces of the drawing in relation to the paper.

1. The first step is to draw the compositional diagonal lines in order to locate the center of the picture. Then, simplify the main forms into geometric shapes.

2. When you draw compositional lines, make sure that the lines are light so they can be erased once the blocking in has been completed.

2

3. Drawing will be easy to do over the previously drawn geometric lines, just follow the layout. Using a charcoal stick should give you more confidence since it is easy to erase.

3

DRAWING NEGATIVE SPACES

When you draw, you must do more than focus on the shape of the model's body; you must also pay attention to the empty spaces and the negative spaces (inside the shape of the figure). These spaces can be a good reference for correctly blocking in the shapes. The empty spaces share outlines with the figure, and when you draw these outlines you are actually drawing the spaces too. If the negative spaces do not have the same shape as the actual model, then the drawing is not in proportion. You must include them, since both the positive shapes and the negative shapes completely fill in the format.

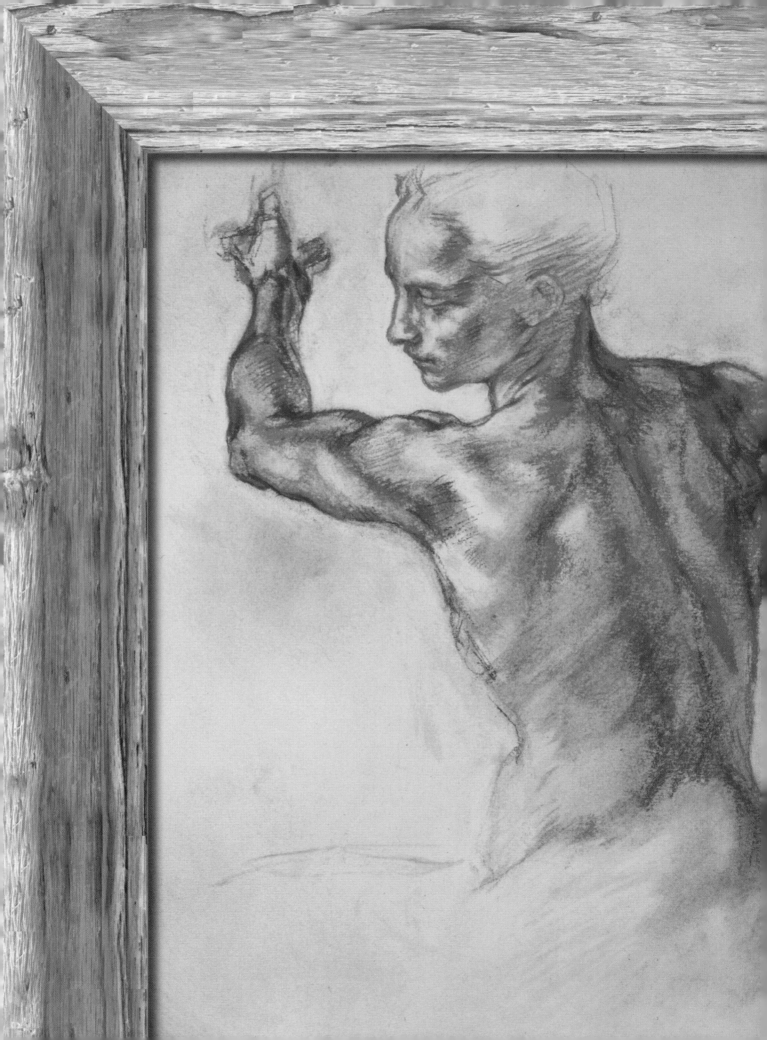

Imitating the Technique

When we have the opportunity to see drawings made by the great masters of any era in an exhibition, we are always surprised by their ability, how ingenious they are at capturing reality, and the skill and creativity they demonstrate in representing effects that add an expressive and realistic character to their work. Drawings, unlike paintings, exhibit interesting information about how they were made, and the steps that were followed in creating the image, thanks to the still visible lines used for blocking in. The repeated and erased lines also reveal interesting information about corrections made during the drawing process. However, the challenge of faithfully copying a drawing can create a few doubts on how to proceed, the best kind of paper to use, how much pressure to apply, and how to interpret the particularities of the artist's style. These and other questions will be answered in the following exercises, where you will be copying a selection of very significant drawings from different styles and eras. If you follow the technical suggestions regarding each process, it will doubtless make the work of copying much easier.

Hendrick Goetz (1558–1617), who would later change his last name to the Latin Goltzius, is considered to be an outstanding artist and the best engraver in the Low Countries working in the Northern Mannerist style. As a child, he suffered severe burns on his right hand, leaving his fingers stiff and malformed. Despite this handicap, Goltzius was one of the foremost draftsmen of his time. In these four studies he represented his injured hand in different positions. Goltzius created his own work in the Mannerist style, as he had a taste for disjointed, tortured, and somewhat deformed shapes, preferring tension and twisted forms to natural ones. The media used for this exercise include charcoal and black and sanguine chalk pencils.

Four Studies of Hands
by Goltzius

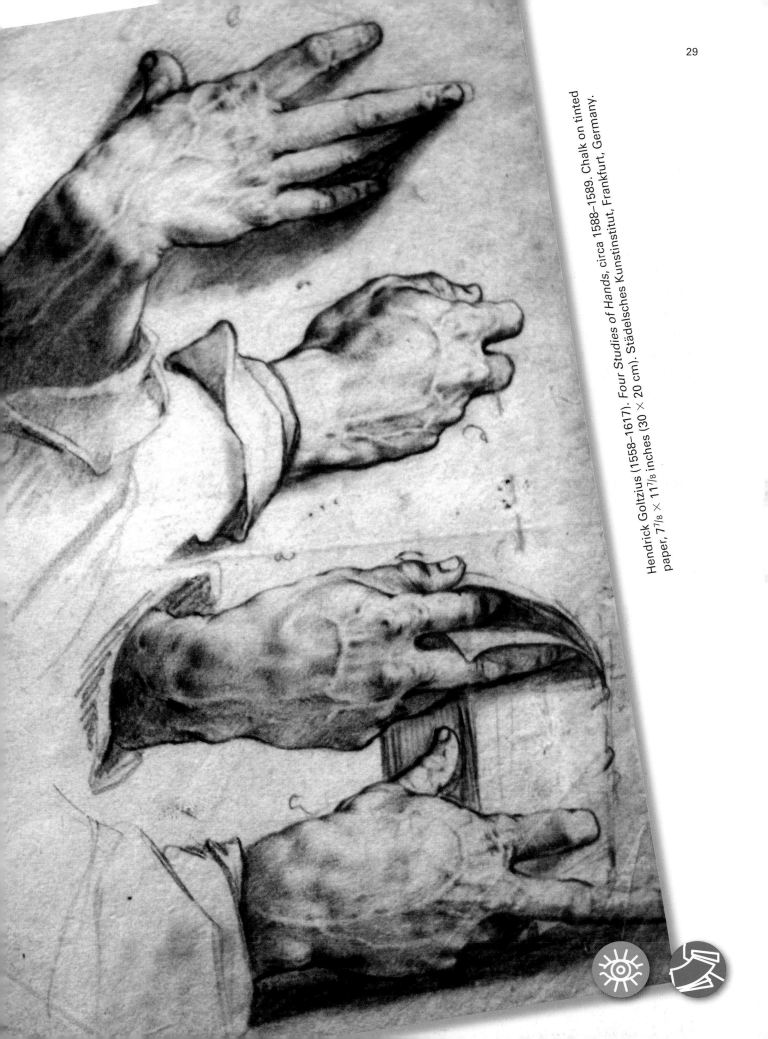

Hendrick Goltzius (1558–1617). *Four Studies of Hands*, circa 1588–1589. Chalk on tinted paper, 7⅛ × 11⅞ inches (30 × 20 cm). Städelsches Kunstinstitut, Frankfurt, Germany.

Accurate Blocking In with Charcoal

Goltzius is recognized for his refined and subtle technique, as well as for the exuberance of his compositions. However, in the following exercise we will not get carried away with twisted shapes or the complex tensions in hands. First we must lay out a sketch or do some blocking in by means of a very simplified drawing that will place each member on the support, indicating the gesture and the proportions. We will use a charcoal stick that can be erased and corrected until arriving at a convincing initial sketch. Although it looks like just a few lines, it is important to spend a lot of time to ensure a successful drawing. This exercise was done by Gabriel Martín.

1. Goltzius drew these hands on a previously tinted paper, so we will proceed in the same manner. In a small dish, prepare a very light mixture of violet and burnt umber and then use it to cover the entire support.

2

Curiously, his injured hand allowed him to more easily grasp his drawing tools, giving him better control of his strokes and line work.

2. The damp paper will buckle but will flatten out once dried, as its natural tension returns. Use a thin stick of charcoal to sketch the hands with very simple lines and geometric outlines.

3

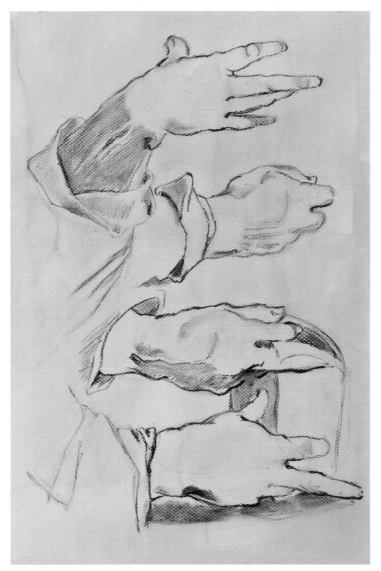

4

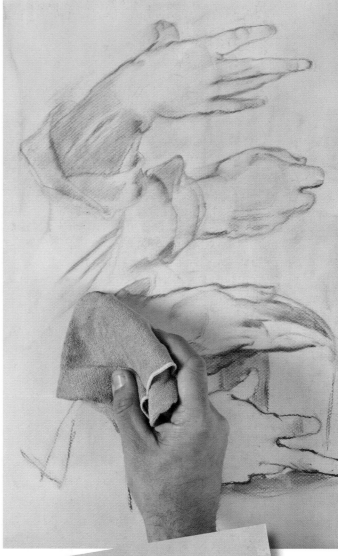

5

3. Continue working on the sketch, adding more rounded shapes that more accurately depict the anatomical outline of the hands. Take advantage of the soft charcoal to add the first shaded areas, which are spread by rubbing with your hand.

4. Wipe the entire drawing with a clean cotton rag. The initial drawing will not disappear; a lighter version will remain on the paper. The exercise will continue using chalk pencils.

5. Go over the outline of the hand with a sanguine pencil and add a bit of shading. Make the outline dark and the shadows very light, using the point of the pencil to create simple strokes.

From Light to Dark

There is a logical order to depicting the volume of the hands. The first step would be developing the entire range of middle tones with the sanguine pencil, then increasing the contrasts by giving the shadows greater depth with a black chalk pencil. This will give the parts a very strong and convincing volume that emphasizes the anatomy and the relief on the flesh of each hand. The sharpened points of the chalk pencils will allow you to be more exact and delicate with the details.

7

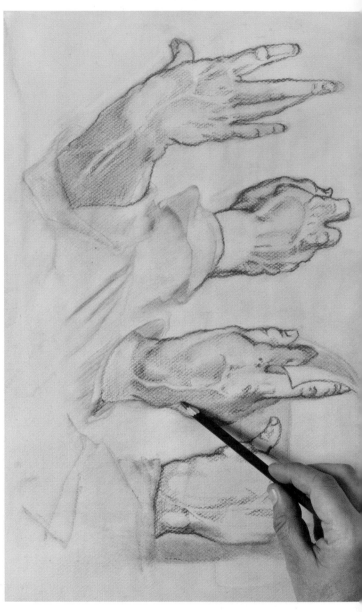

6

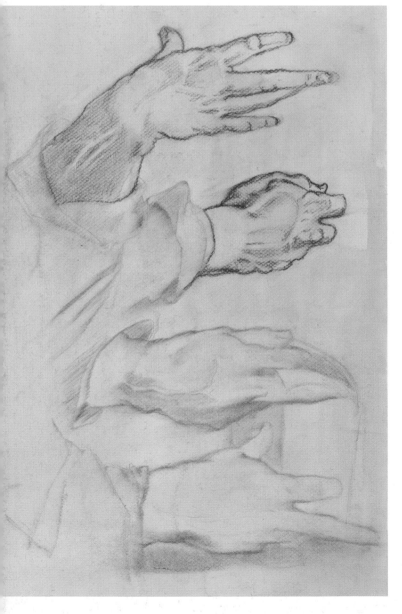

6. In the second phase, use only the sanguine pencil, which will blend with the light lines of the underlying charcoal. The reddish color will be used to represent the middle tones while the most well-lit areas will be represented by the color of the paper.

7. Use the side of the sanguine pencil to avoid applying too much pressure. This will create delicate shading and will not leave any lines on the paper.

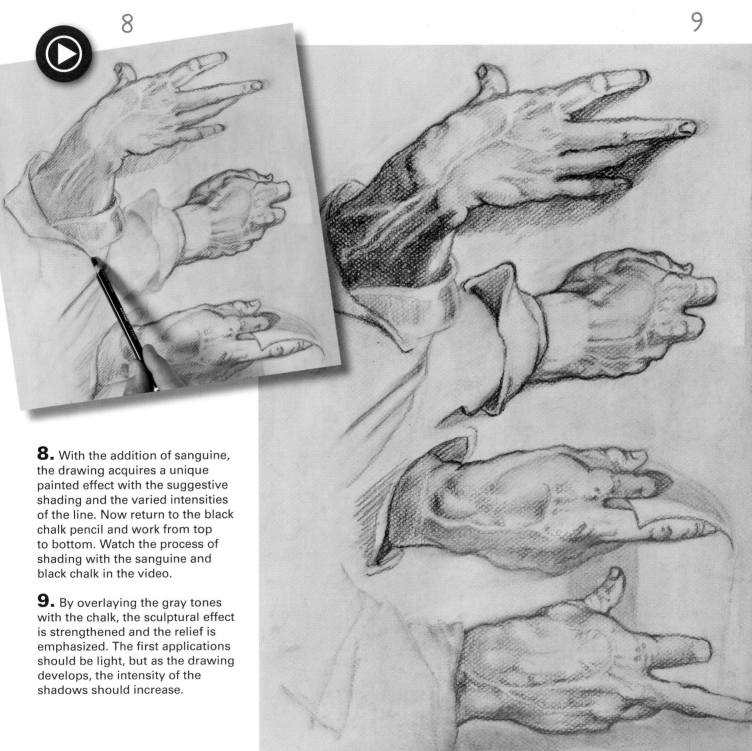

SHADING THE OUTLINE

The surface of the hand has many shapes, hollows, and textures, so it is important to modulate the shading and apply the appropriate intensity to each part, creating light gradations and leaving the color of the paper for the visible veins, shading only their edges.

8

9

8. With the addition of sanguine, the drawing acquires a unique painted effect with the suggestive shading and the varied intensities of the line. Now return to the black chalk pencil and work from top to bottom. Watch the process of shading with the sanguine and black chalk in the video.

9. By overlaying the gray tones with the chalk, the sculptural effect is strengthened and the relief is emphasized. The first applications should be light, but as the drawing develops, the intensity of the shadows should increase.

Darkening, Details, and Exaggerations

The style of Goltzius is very exaggerated; he liked ornaments and emphasized musculature, to the extreme. Consequently, the shading and black chalk lines in the final phase should represent the relief of the skin in great detail, with its folds, wrinkles, and prominent veins. The idea is to highlight the artist's sophisticated graphic language, which gives great strength and depth to each one of the positions adopted by the hand. Work with pencils that have very sharp points.

IO

II

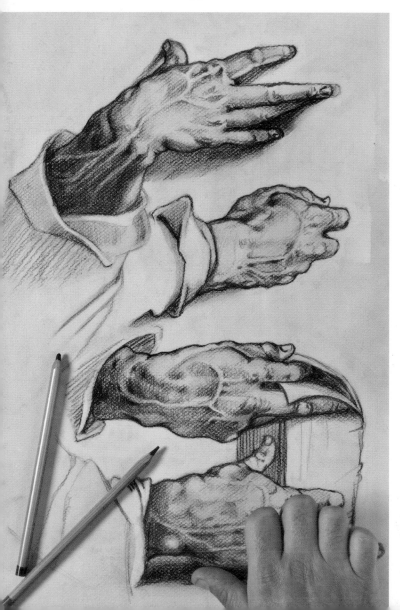

10. Make gray tones with the black chalk that overlay the other areas shaded with sanguine; both colors will blend to create a glazing effect. Go over some lines with dark black strokes while defining others with sanguine. You will see in the video how the shading progressively darkens the skin tones.

11. The darkest shadows are those of the wrist and those projected by the hand. The latter form a more dense layer of color and look like a gradation with edges that are somewhat blurred. This is achieved by blending the colors with your fingers. Use just a few lines to represent the look that can be seen at the bottom part of the drawing.

The final lines are made by alternating both color pencils to create the details of the skin. Use a rubber eraser to remove smears and accidental lines from the outlines of the hands. Then your copy of the Goltzius drawing can be considered finished. He was a great master who drew with the confidence that comes with being a good painter and an excellent engraver.

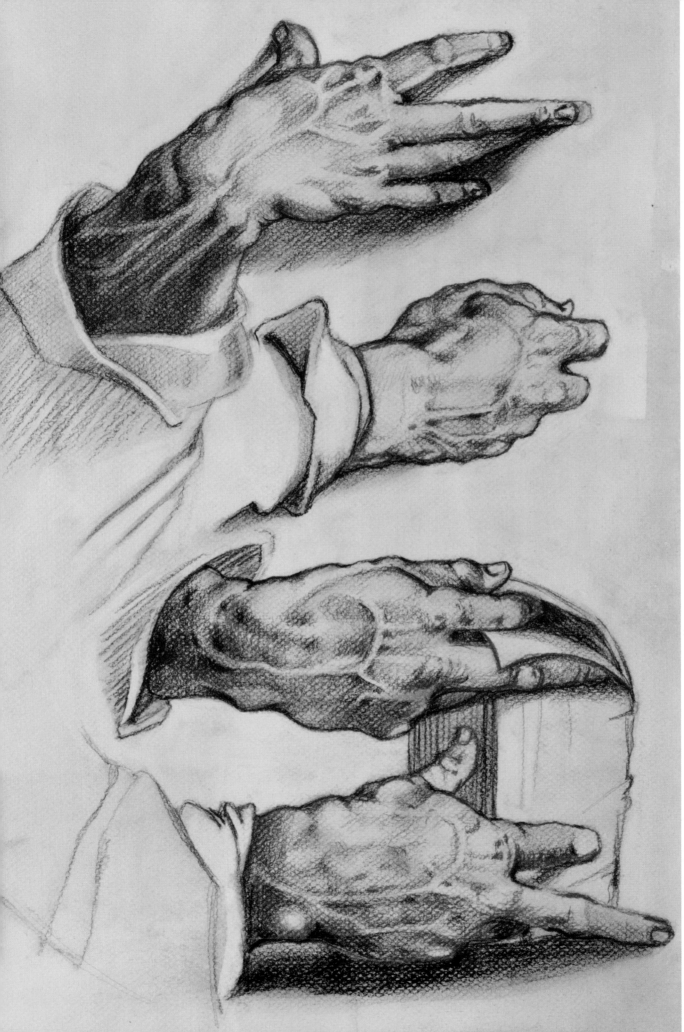

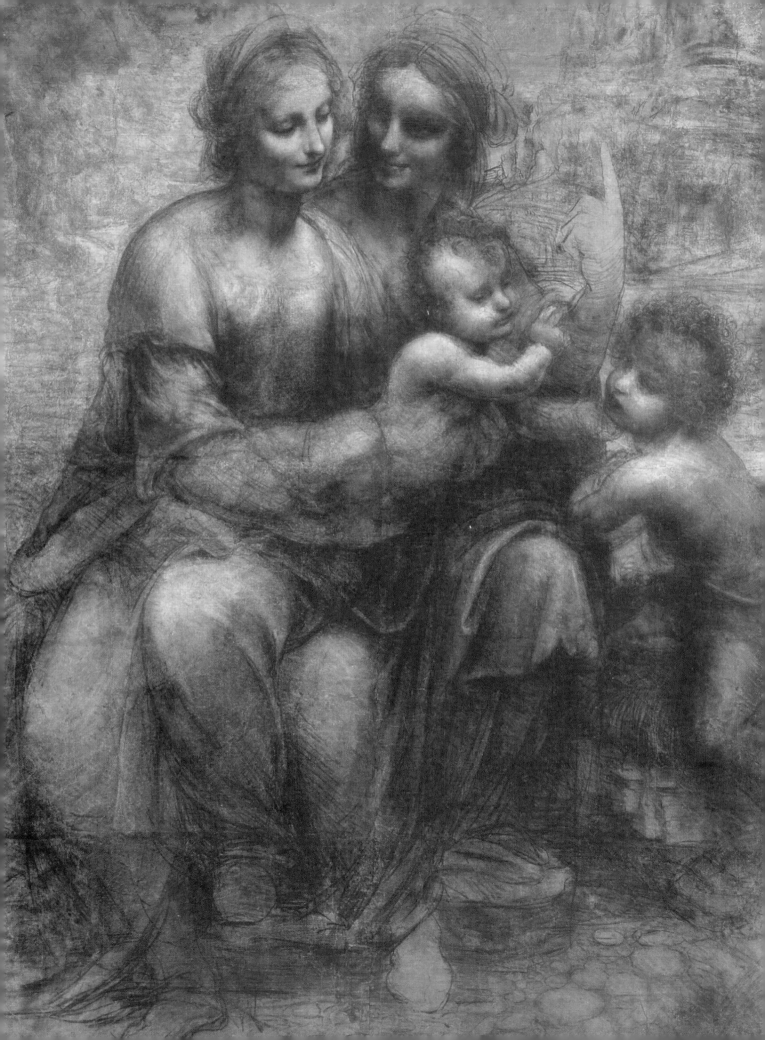

The Burlington House Cartoon by **da Vinci**

This drawing, which is considered to be one of the greatest masterworks of all times, has been copied by many generations of art students. It is exhibited at the National Gallery in London, where it is called *The Burlington House Cartoon*, which is the headquarters of the Royal Academy. There is no evidence that the artist made a painting based on this drawing, but there is a work that looks quite like it: *The Virgin and Child with St Anne*, which is hanging in the Louvre Museum in Paris. The important qualities of this cartoon include innovative drawing techniques employed by da Vinci: a great sense of composition, skillful use of blending, a vast knowledge of human and animal anatomy, botany, geology, and his use of light to model the figures and faces, his interest in physiognomy, and the ability to depict the way humans gesture and express emotions. In other words, a work where he gathers everything in a small space and creates a huge challenge for any and every copyist. The original drawing used black chalk and white lead, which were blended on eight sheets of paper, glued together.

Leonardo da Vinci, *The Virgin and Child with St Anne and St John the Baptist*, circa 1499–1505. Black chalk and white lead on paper, 55³/₄ × 41¹/₄ inches (141.5 × 104.6 cm). National Gallery, London, UK.

Changing the Format and the Materials

In da Vinci's time, a sketch required a lot of physical strength, especially if it was made on a very large support, like this cartoon that measures over a yard and a half high. A good idea would be for the copyist to reduce the size of this sketch for better control of the support and the lines. Similar to adjusting the size of the format, you can also drop the black chalk and white lead in favor of pigment sticks that are more popular and easier to find, for example, charcoal, chalk, and sanguine crayons. Used skillfully, they can create a drawing that is as attractive as the works of Leonardo. This exercise was done by Mercedes Gaspar.

1. The support for this drawing is Canson paper in a beige color. Do the preliminary blocking in freehand with a stick of charcoal. Fold the photograph or photocopy in half to focus on the figure on the left and to ensure a well-proportioned sketch.

2. Drawing with charcoal allows you to redraw, retouch, and correct lines as many times as necessary until you are happy with your results. You must not limit yourself to lines alone; here, the shading is combined with light strokes and other darker ones.

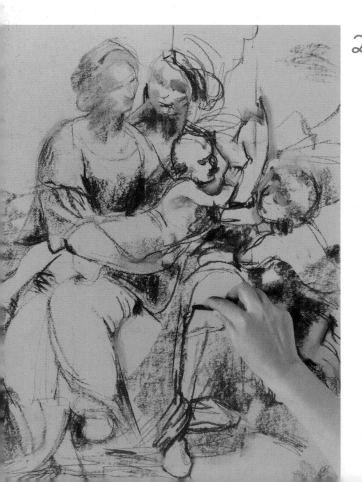

THE RAG AS A DRAWING TOOL

Scrape two sticks of sanguine over a sheet of paper to reduce the pigment to powder form. Then dip a rag with the powder to use it as a drawing instrument.

3

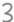

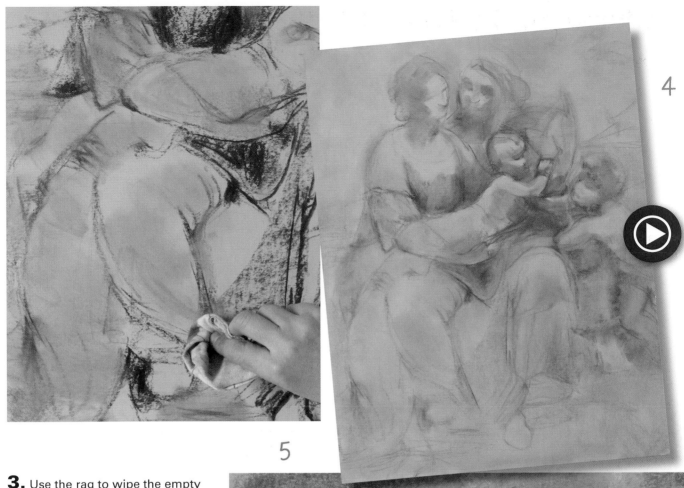

4

5

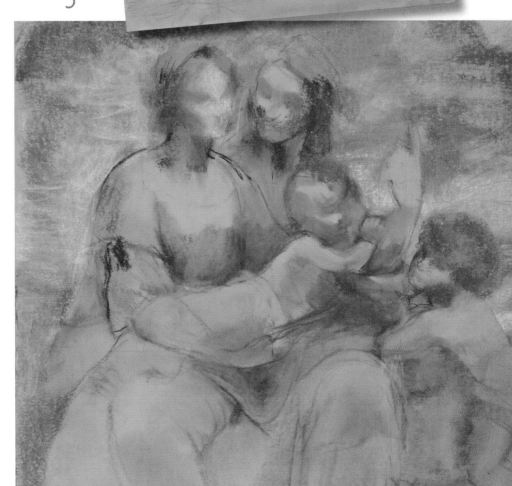

3. Use the rag to wipe the empty areas where the color of the paper is shown so that the overall tone of the drawing is similar to that of the original.

4. Blend the sanguine color with the charcoal strokes to create a blurred image of the figures, which look like they are indicated by just a few faint lines. See the process on the video.

5. The main goal is to represent the background, which is a landscape that is heavily blurred. The gray tones are achieved by applying shading with charcoal, white chalk, and streaks of sanguine. The color of the paper should be visible among the applications of color.

Practicing the Blending Technique

Above all else, Leonardo da Vinci excelled at the summate technique, as well as combining light and shadow. His figures do not look solid but rather evanescent, light, and well integrated into the background. He established a perspective by discreetly mixing the outlines of the figures with the background. For this reason, in this phase of the drawing, it is important to make use of the blending stump to make the images look unfocused, even though they are in the foreground. The white chalk highlights do not act as intense impacts of light but as illuminated areas that softly transition to shadow.

7

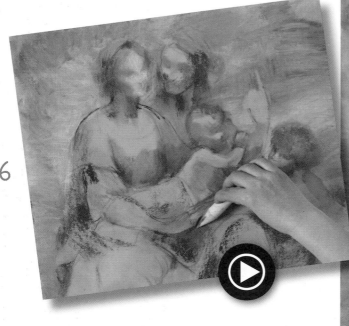

6

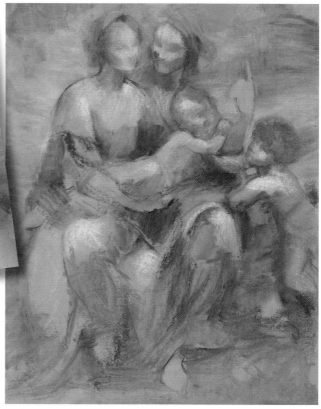

6. After applying additional shadows with the charcoal, blend them with a rag or a blending stump. This will create the blurred or softened effect and will also drag the pigment to model the forms of the bodies and clothing. Watch the video to see how the details are created.

7. Take care to not rub so much that you mix the colors, as they could end up as dirty dark grays. The white chalk highlights should be blended with your hand or with the tip of the blending stump to avoid muddying the colors.

8. Carefully sharpen the charcoal, then go over the lines that define the outlines of the figures. The sharp point will allow a more precise drawing of the face of the figure on the left. The lines should be very light and extremely thin.

8

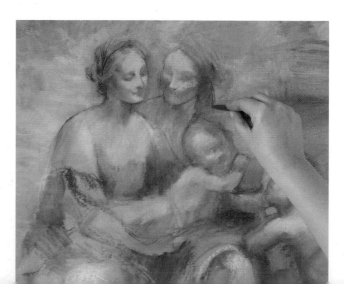

9

As the work progresses, you will use more chalk; in this case, the mid tones on the child's body are created with a reddish sanguine.

9. Use a burnt umber color chalk for the outlines and darkest shading on the child.

10

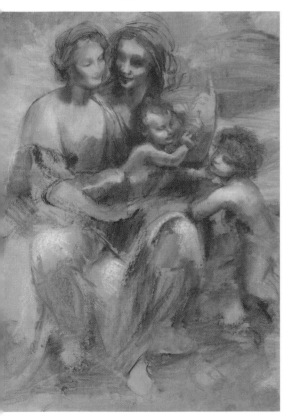

10. The darker the shadows, the greater the effect of relief. This will become evident as you work on the women's heads and bodies, using sanguine and burnt umber and gently blending them with the blending stump.

11. After the shadows, you can add more definition to the faces of the four figures. Use a sepia color chalk pencil combined with an orange sanguine color pencil to apply soft reflections of light in the hair. These touches will help the figures stand out from the background.

11

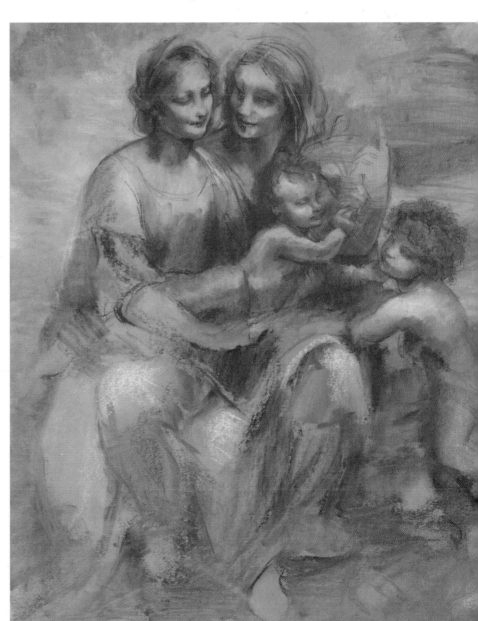

12

Details, Texture, and Sweetness

In this final phase, we will resolve the details. It is important to pay close attention to the inclination of the heads because there is a subtle relationship among the four figures, in the construction of the hands, the texture of the hair, and the drapery of the vestments. da Vinci created this drawing during the time he was working on the *Mona Lisa*, which explains why there is a great similarity between the face of the *Mona Lisa* and these female figures. The blending should be done very lightly with no pressure, applying the point on the faces to soften the expressions and skin texture. The scene should emanate delicacy.

12. For the final blending, try to represent soft and smooth skin with gradations made with the blending stump. As you work, incorporate white chalk lines into the scene to soften the transitions from one color to another. Add some light shading to the clothing with charcoal and sanguine.

13. Work on the drapery, emphasizing the dark areas to distinguish the folds. This will contrast with the greater lightness of the tones on the rounded areas of the knees, which receive the impact of direct light. The charcoal lines should be fluid and of varying intensity, according to the value of the adjacent shading.

14. Soften the charcoal strokes to create mid tones with sienna color chalk. Don't worry about adding more detail to the bodies of the two adult figures since they are not very clearly defined. The heads of the two women seem to emerge from the same body, as if two people were blended into a single complex element. Also, we can barely distinguish the legs of the child that is being held.

13

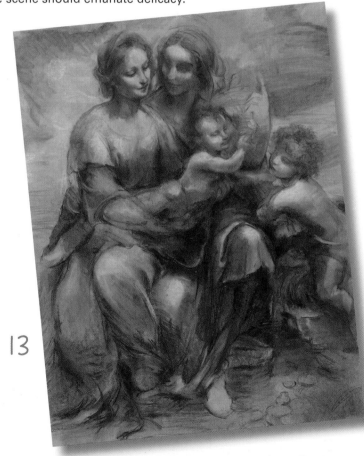

14

The texture of the ground is barely noticeable with a few quick strokes, while the landscape in the background is just sketched, as if it were an abstract composition. The curls in the children's hair are an accumulation of voluptuous spiral lines. The expression of the Virgin Mary is extraordinarily tender, but at the same time her face has a majestic beauty, suggesting a deep maternal devotion. The original color of the paper has been darkened by spraying the finished drawing with a fixative.

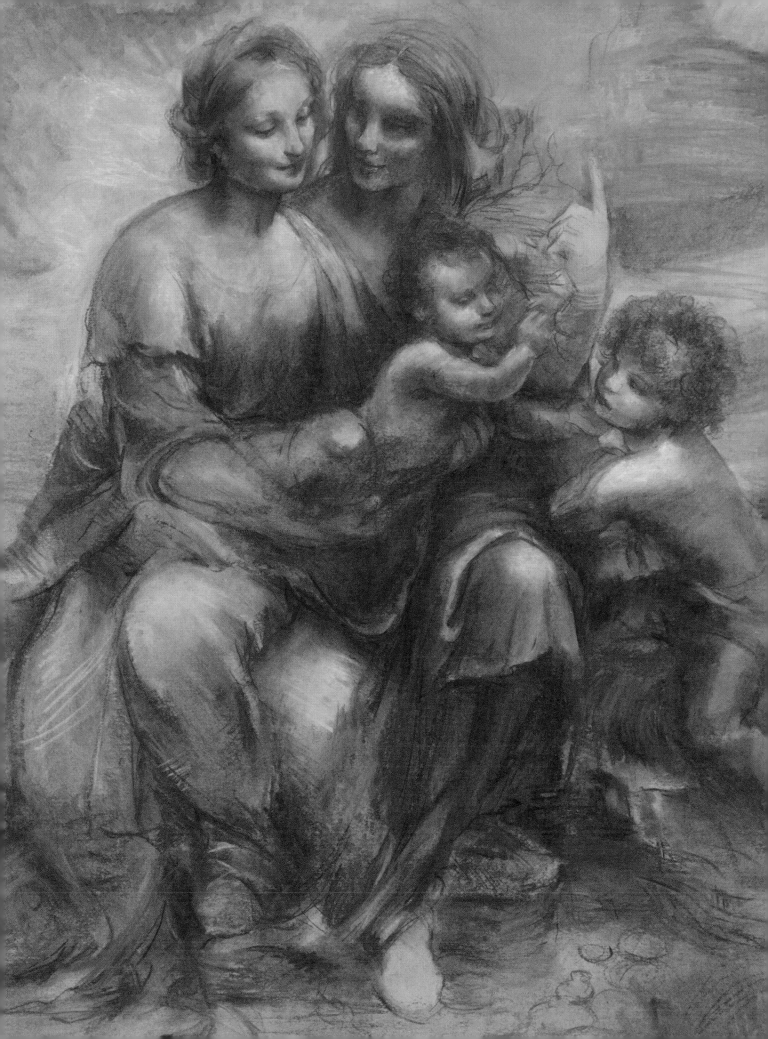

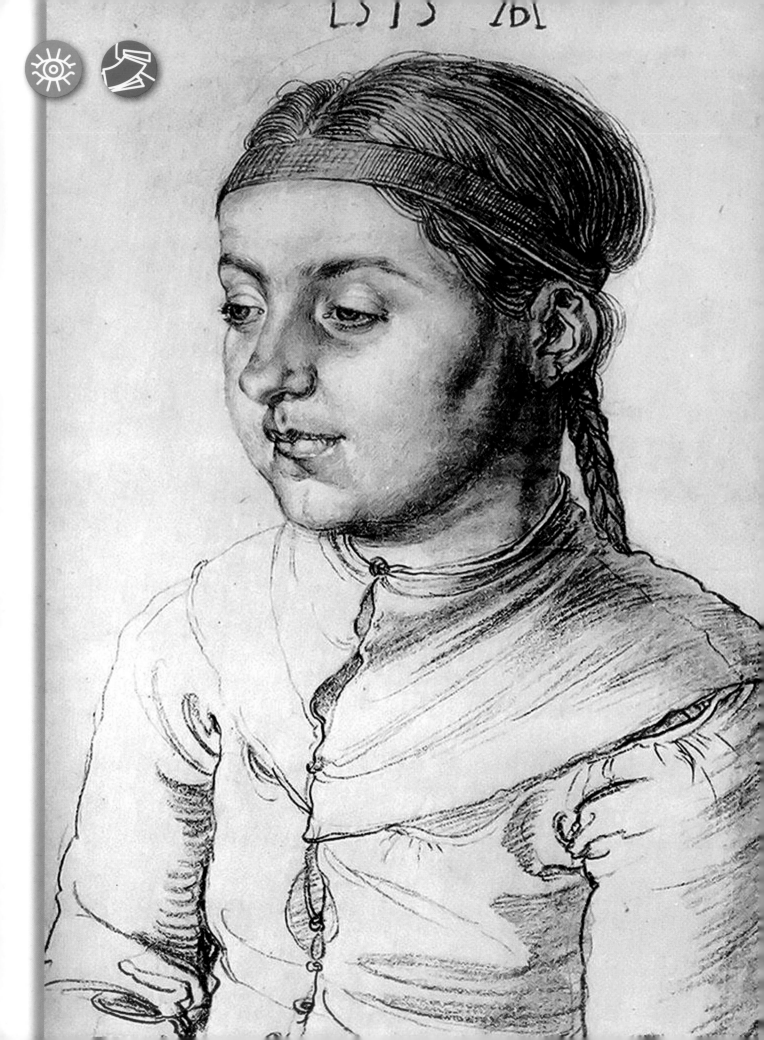

Portrait of a Girl by **Dürer**

Albrecht Dürer (1471–1528) is the most famous artist of the German Renaissance, very well known for his paintings, but above all else for his exquisite prints and drawings. A good example of this is the portrait of the young girl that we will use in this step-by-step exercise. The goal of a copyist is not to falsify, but to copy and enjoy recreating the techniques of the artist. For this reason, we can modify the dimensions of the original, and if we wish, replace the original technique with another that is easier and more convenient. This exercise, which Dürer created completely with charcoal and fine grain paper, will be done using graphite pencils on a satin finish paper, aiming for the same effects and overall results that were achieved by the artist.

Blocking In with Light Lines

In Dürer's work you can see his enormous skill in drawing and the meticulous details. This work also requires many sinuous lines in the initial sketch, with light strokes and barely perceptible lines that will later be made more prominent as the exercise progresses. Using an HB graphite pencil for positioning the young girl in the portrait, its lines will be light and easy to correct with an eraser. Blocking in is the most important phase of the drawing, because if you don't achieve the proportions and likeness of the young girl's features, there will be no way it can be corrected by shading or modeling. Therefore, close attention is required. If you run into difficulties, you can use some of the helpful techniques for blocking in that are explained in the first part of the book. This exercise was done by Teresa Seguí.

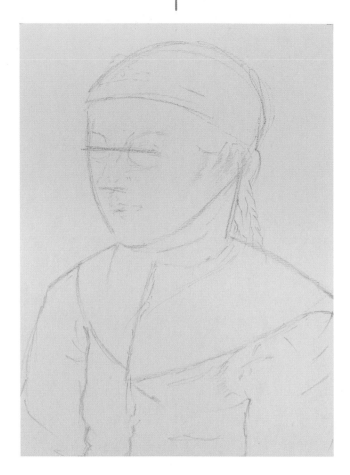

1

2

1. Draw the oval of the head, the neck, and the lines of the shoulders and arms with an HB pencil. Build on these first lines by creating additional ones. Draw a series of horizontal lines at the approximate location of the facial features: the hairline, the eyes, the nose, and the mouth.

2. Draw the facial elements in more detail over the initial sketch and placement lines, but make them half-finished with a fine line that is still not definitive. This phase requires meticulous work and adjustments, erasing and correcting until you are able to capture the features of the model.

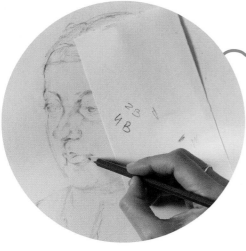

PROTECTING THE DRAWING

Graphite pencils are not the same as charcoal. Therefore, you should not try to create the dark lines of the model. It is better to create the drawing little by little and then apply the final lines near the end of the exercise. Place a piece of paper underneath your hand to avoid smudging your drawing accidentally.

3

4

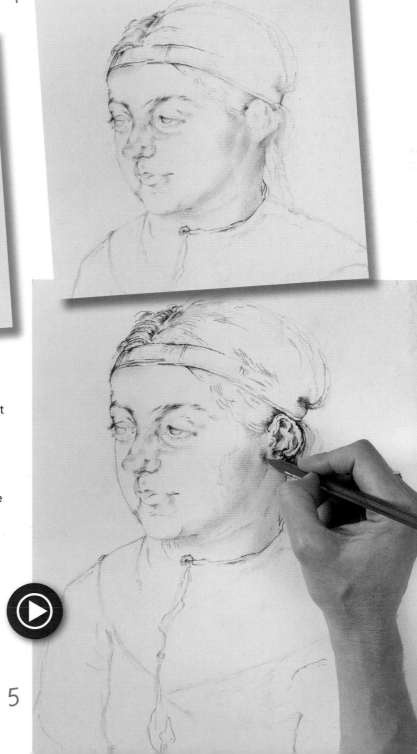

5

3. While the lines indicate the facial features very precisely, the first shading can begin in the lower part of the head. Apply light grays with the side of the pencil and then blend it with your fingertips.

4. Continue to work with a 2B pencil. Use the sharp point to draw the tip of the nose, the upper part of the eyebrows, the band on the head, the hair, and the wavy lines of the dress. Go over the initial lines with a medium gray tone to make them more visible.

5. Carefully work on the details of the ear, emphasizing its shape with darker shading. You will be applying much more pressure with the pencil point than before. It is very important that the point be sharp to ensure precise lines and shading. Watch the video to see how to proceed with the nose.

Controlling the Line and Shading

Dürer controlled the charcoal stick and silverpoint with such delicacy that the drawings from this stage of his life contain double or triple the number of lines per square inch than earlier ones. At the edges, the lines overlap one another and enhance the solid outline of the figure. The shading is light, well modulated, but not very contrasting, much different from the chiaroscuro that is typical of the Baroque period artists. In this case, the drawing should progress gradually, each area darkened little by little with light lines and barely perceptible changes in tone.

6

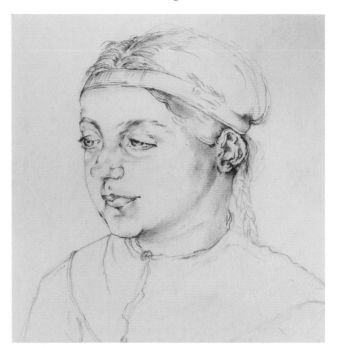

7

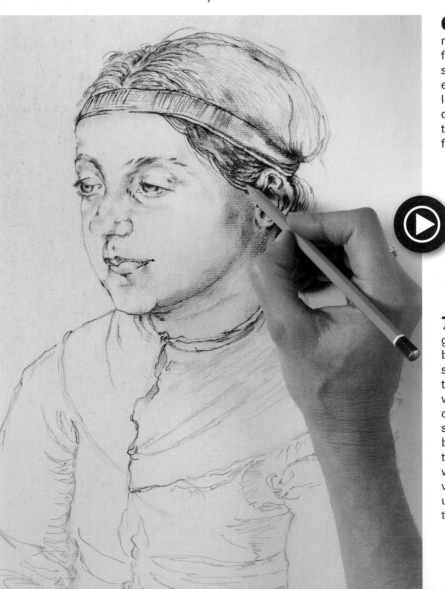

6. Now the work should focus mainly on the head and the features of the face, where you should darken the girl's melancholy expression with new overlaid lines. The simplicity of the interior drawing and shading demonstrates the intention of putting the main focus on the form.

7. Continue drawing with a 4B graphite pencil sharpened with a blade or craft knife. Reinforce the shadows by working on capturing the different textures of the hair with wavy lines that follow the direction of the hairstyle and strokes that are parallel to the hair band. For shading on the face, hold the pencil at an angle to use the widest part of the lead. Watch the video to see how the technique used on the hair is different from that used for modeling the face.

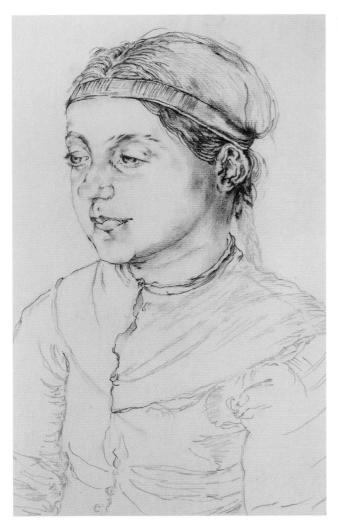

8

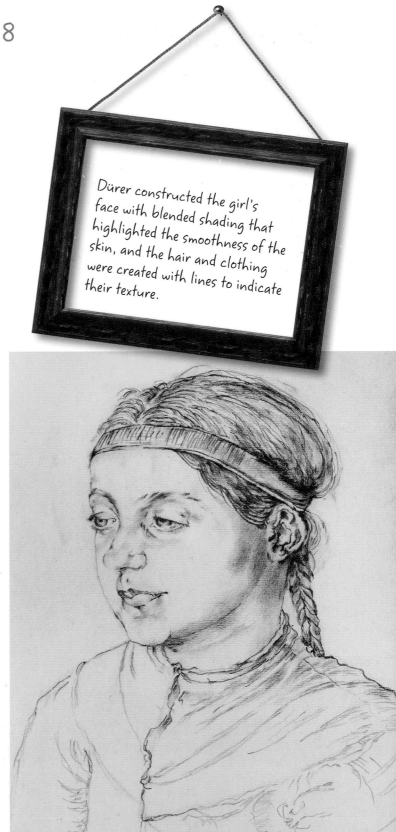

Dürer constructed the girl's face with blended shading that highlighted the smoothness of the skin, and the hair and clothing were created with lines to indicate their texture.

8. The head is now correctly defined with a delicate outline created with fine lines, and the blended light shading gives the facial features a sense of volume. The lines should be darker in the shaded area that is near the ear than at the top of the head, which is in direct light. Now start on the main lines of the dress.

9. Complete the construction of the hair and the braid. Using very light lines made with the side of the pencil point, shade in the small folds of the dress on the girl's shoulders.

9

Focusing the Work on the Face

Dürer always felt more comfortable as a draftsman or graphic artist than as a painter, and this can be seen in his work, where he demonstrates that he is a master at modeling without color. A very common approach in that era was to put a great amount of effort into drawing the face while leaving nearby areas of the figure unfinished. For example, the dress is drawn with more linear forms and minimal applications of pencil shading. This approach directs the viewer's eye toward the face rather than to the superfluous details of the dress.

10

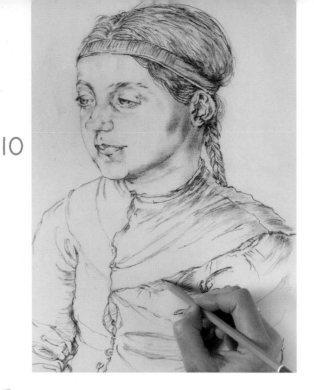

11

12

10. Dürer was very much a realist artist down to the most minor details, and this can be appreciated in the work on the dress, clearly linear and very aware of the parted seams, folds, the tensions in the fabric, and the button that has come open.

11. The dress strokes are linear, and the modulations seen in the lines are made by alternating the pressure applied to the pencil point. The lines on the face are sweeter, less harsh, and they are integrated with the shading by lightly rubbing with the fingers. The blending stump should not be used here.

12. The drawing is nearly finished. All of the elements seem to be clearly represented; however, the overall drawing still does not have the appropriate general tone. It looks somewhat lighter than the original model and some of the texture still needs to be worked, especially in the hair.

To complete the drawing, we need to firm up some of the details on the dress, the lines of the hair, and to darken the shaded areas. This portrait, like others made by Dürer in Germany during the Reformation, is characterized by an interest in representing the spirituality of the subject. There is an attempt at showing the true inner person, avoiding any idealization.

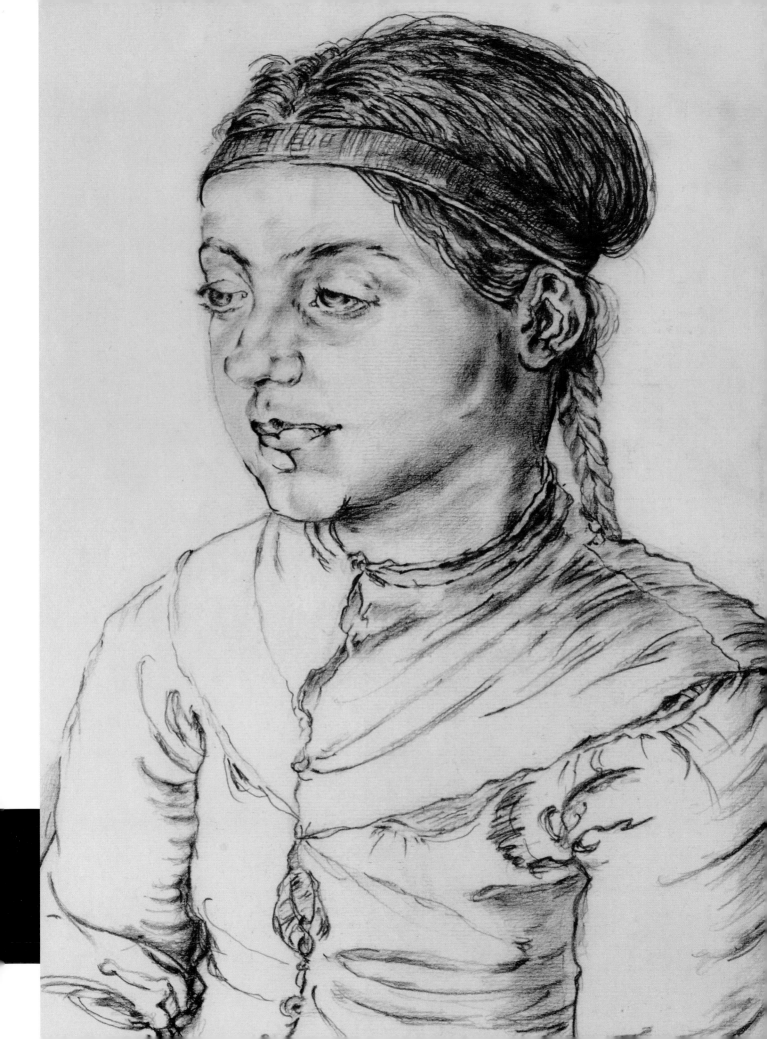

Head of a Young Apostle by **Raphael**

This drawing by Raphael Sanzio, also known as Raphael de Urbino (1483–1520), is a very important work among those produced by the Italian master. This auxiliary cartoon was created for the last painting he made, *The Transfiguration*, one of the great works of the Renaissance that can be seen in the Vatican Museums. This head is just one of the magnificent preparatory drawings that Raphael created for this project, whose purpose was to explore the most subtle details of the figures. He made quick sketches as well as more detailed ones that were later turned into large-scale studies, where he perfected the details and the modeling of the flesh tones. This head, a faithful rendering of the head of a young apostle, is seen in a three-quarters view. The facial expression, somewhat idealized, is lively and precise, with downcast eyes but an attentive and relaxed gaze, observing something nearby.

Raphael Sanzio, Head of a Young Apostle, circa 1519–1520. Black chalk on paper, 14½ × 11 inches (37.5 × 27.8 cm). Private Collection.

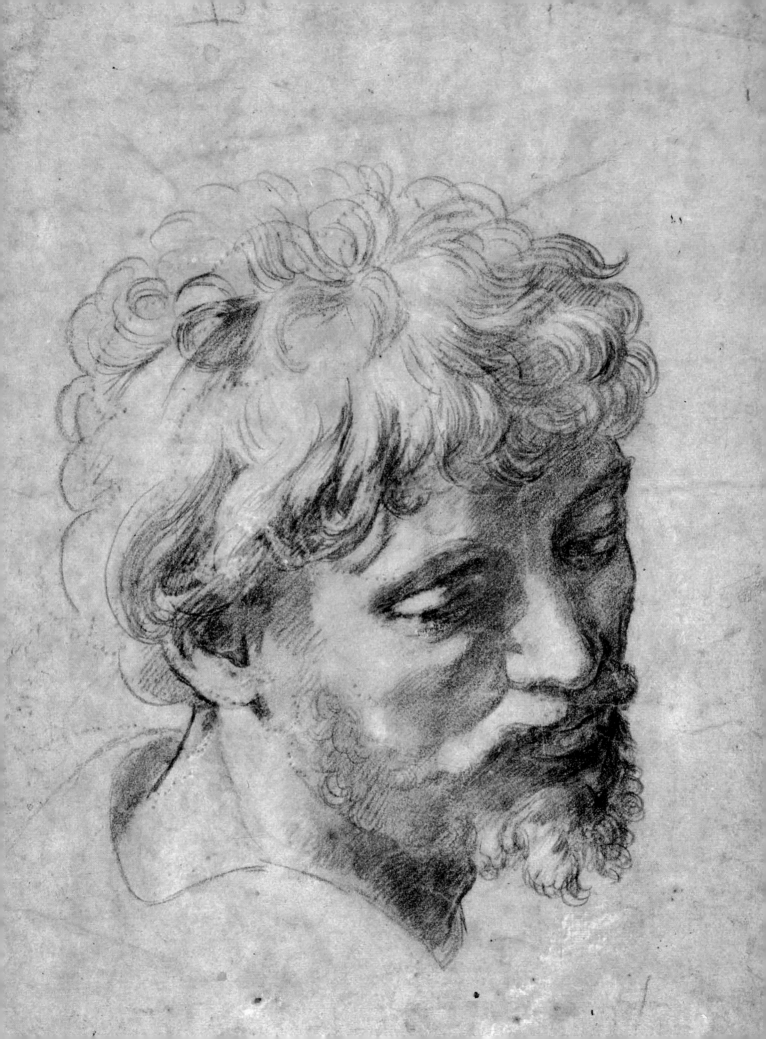

Method and Background

The drawing material employed by Raphael was black chalk, a natural mineral that was often used during the 16th century, although at that time it was manufactured in an artificial form based on charcoal. This material, which is not available anymore, produced an intense black line and tore the support because of the grainy impurities it contained. It was very similar to compressed charcoal, which we will use in the following exercise. But first, we will tint the paper with a watercolor wash to create a tone similar to that of the aged paper of the original drawing. This exercise was done by Gabriel Martín.

FINDING THE TONE OF THE PAPER

Experiment with washes on a piece of paper with the same characteristics as the one you are going to use for the drawing. The goal is to find the appropriate color and tone for the background.

1. Attach the paper to a wood support with adhesive tape, and make sure it is pulled tight before applying the watercolor wash. The layer of color does not have to be uniform; it is better if it is slightly different from the aged paper.

2. The copy will be made at a larger size than the original, but it will be more comfortable and you won't have to work on the small details. After the watercolor is completely dry, block in the head with very simple lines drawn with a stick of charcoal, which will allow you to erase and correct by just wiping it with a rag.

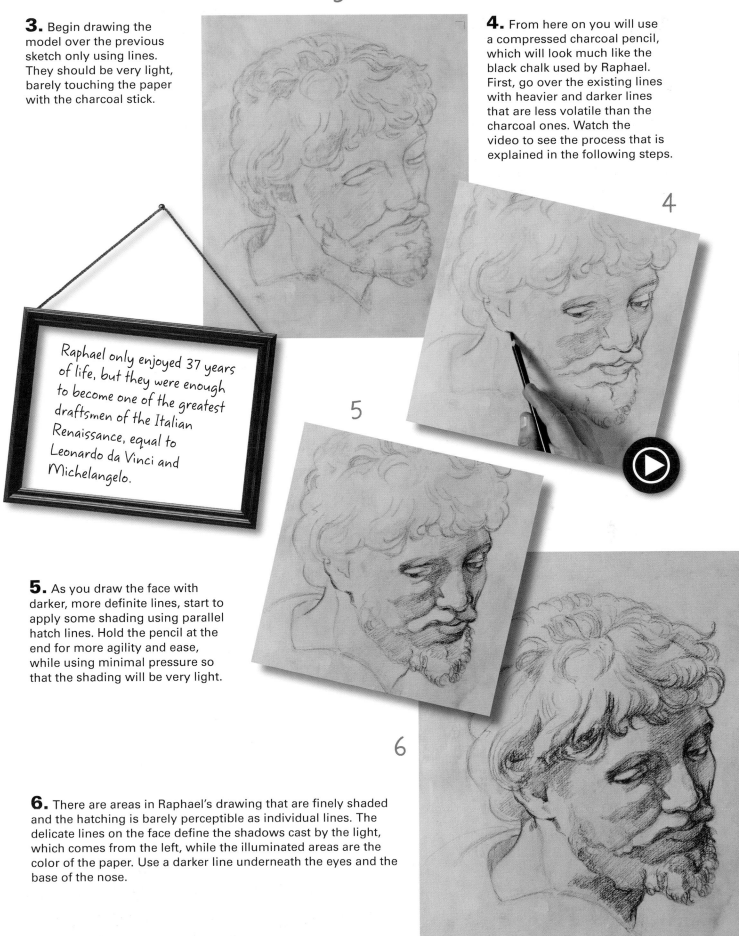

3. Begin drawing the model over the previous sketch only using lines. They should be very light, barely touching the paper with the charcoal stick.

3

4. From here on you will use a compressed charcoal pencil, which will look much like the black chalk used by Raphael. First, go over the existing lines with heavier and darker lines that are less volatile than the charcoal ones. Watch the video to see the process that is explained in the following steps.

4

Raphael only enjoyed 37 years of life, but they were enough to become one of the greatest draftsmen of the Italian Renaissance, equal to Leonardo da Vinci and Michelangelo.

5

5. As you draw the face with darker, more definite lines, start to apply some shading using parallel hatch lines. Hold the pencil at the end for more agility and ease, while using minimal pressure so that the shading will be very light.

6

6. There are areas in Raphael's drawing that are finely shaded and the hatching is barely perceptible as individual lines. The delicate lines on the face define the shadows cast by the light, which comes from the left, while the illuminated areas are the color of the paper. Use a darker line underneath the eyes and the base of the nose.

7

The Spirit of the Original Model

The juxtaposition of the very detailed areas against the ones that are barely sketched in suggests that Raphael's drawing was a study of facial features in preparation for a painting. When he was satisfied with a composition, he often enlarged the cartoon to full scale. To do this he perforated the paper with a punch, leaving holes that could be rubbed with a little soot, which explains the holes in the original drawing. The copyist should be faithful to the spirit of the original drawing and carefully try to achieve the modeling of the shadows on the face while the hair, without tones, seems more stylized, just curving strokes and small wavy lines.

8

7. Apply increased pressure with the compressed charcoal pencil as you shade to create a greater variety of tones and an accurate modeling of the flesh tones on the face. As the shading gets darker, go over the outlines of the lips, beard, chin, and nose with darker lines.

8. Between the lights and the darks there should be some areas of gradual transition, slight gradations that are created by blending the edges of the grays with the tip of the little finger. Be careful not to press hard, as blending done with compressed charcoal tends to become too black. Watch the entire process on the video.

9. When the drawing is nearly finished, use an eraser to clean up any possible errors and to create the highlights in the illuminated areas, which may have been accidentally smeared with charcoal from your hand.

9

The face has an extraordinarily finished look, while the treatment of the hair is looser, done with a few wavy and solid lines, along with swelling curves to indicate curls. A large diagonal application of hatch lines defines the shadows that frame one side of the head and beard. Most of Raphael's drawings were very detailed, with careful, delicate shading that gave his figures a great gentleness.

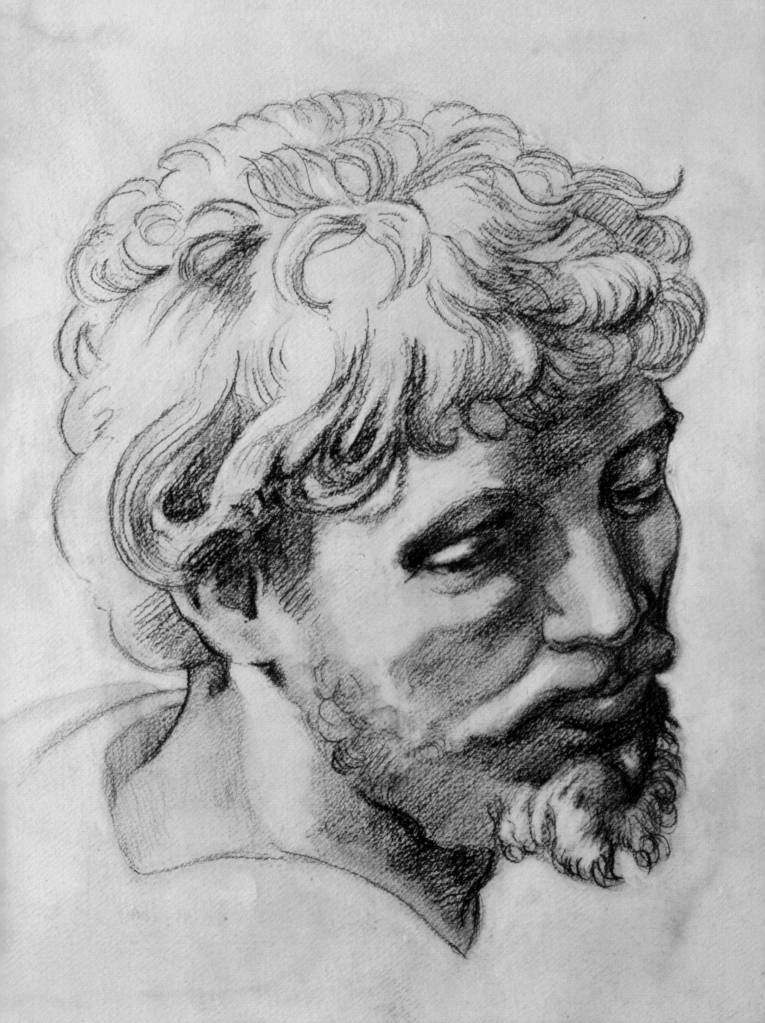

Of all the drawings made by the great artist of the Italian Renaissance, Michelangelo Buonarroti (1475–1564), this piece is one of the most popular. It contains several studies made for one of the scenes that decorate the vault of the Sistine Chapel in the Vatican. The person represented in the center drawing is the Libyan Sibyl, who was a prophet of the pagan world who presided over the Zeus Ammon Oracle. It belongs to a later phase of the preparatory drawings for these spectacular frescos. Here the figure seems to be nude and displays a very muscular torso that is almost masculine. Included with it are other complementary sketches the artist made to focus on some of the details: the delicate profile of the face, the big toe of a foot seen in foreshortened perspective, and a raised hand that, in the fresco, holds the book of the sibyl's prophecies. In this exercise, we will focus our interest on the main figure and ignore everything else.

The Libyan Sibyl
by **Michelangelo**

Michelangelo Buonarroti, *Studies For the Libyan Sibyl*, 1511.
Red chalk, $11^{3}/_{8} \times 8^{1}/_{2}$ inches (28.9 × 21.4 cm)
Metropolitan Museum of Art, New York.

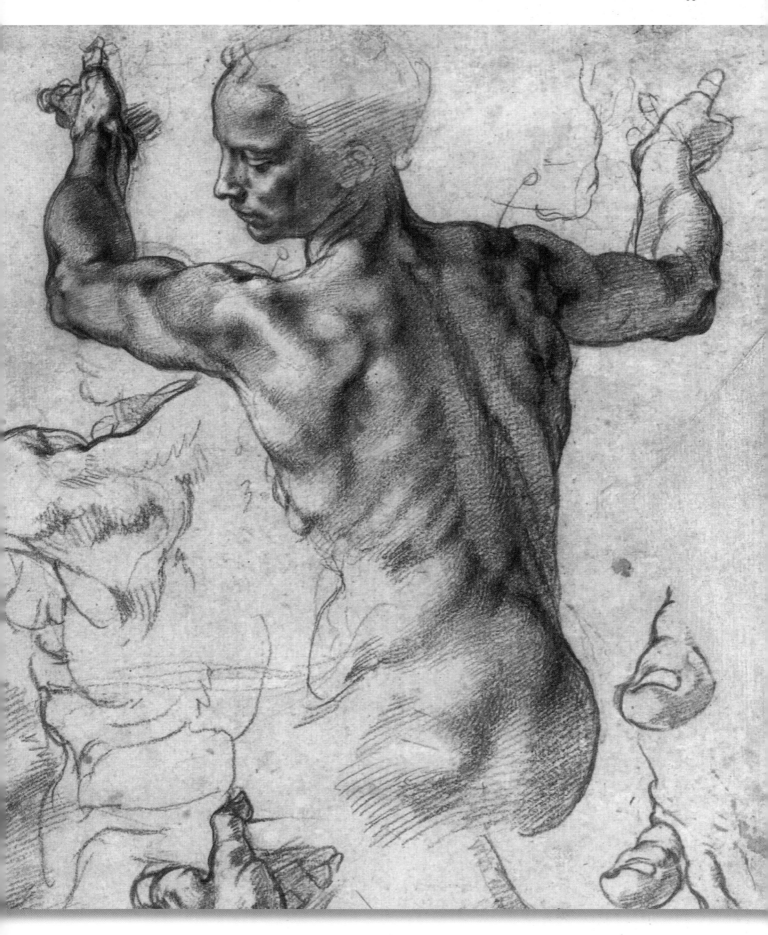

Capturing the Gesture

In this drawing, Michelangelo represents the pose of the Sibyl with such expression and strength that it cannot be ignored: a magisterial turn of the head, the torso from behind with tension, and the arms held high, forming a muscular figure that twists with graceful finesse. This is a simple study for the painted work, which later held the forearm a little lower than in the drawing and the torso more inclined. The main challenge of the first phase of the drawing is capturing the pose with the same strength as the artist did, starting with an accurate initial sketch that combines lines and shading and gives the figure a solid appearance. This will be the base for the complex anatomy, as well as for the very visible and dense shading. This exercise was done by Mercedes Gaspar.

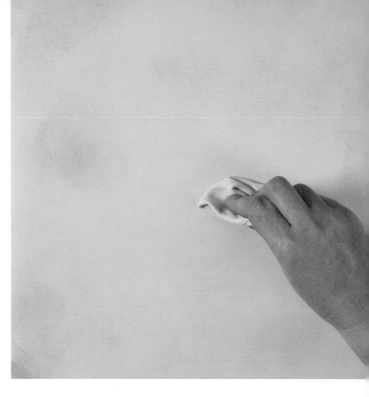

1. Before you begin, tint a sheet of fine grain paper with a similar tone. Without this step, the drawing will seem too contrasting, surrounded by very bright white. To tint, dip a cotton rag in sanguine powder and wipe it on the entire surface of the support.

2. Capturing the pose is instrumental to the success of the copy. Block it in with a stick of sanguine, using very rhythmic but light strokes. Place a strip of paper horizontally over the drawing and over the photograph of the original. This line will help you to calculate the proportions and the surrounding empty spaces.

3. Build up the upper half of the figure over the line sketch, alternating lines with shading that is made with the wide edge of the stick. The outline around the figure should be a bit darker than the interior lines.

2

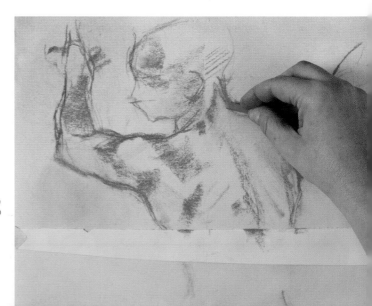

3

VARIOUS TONES

Michelangelo made this drawing with red chalk, which was very similar to the material that we now call sanguine. But instead of using a single tone of this reddish color, you should use several tones so you can develop a much wider range in order to represent the volume.

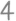

4

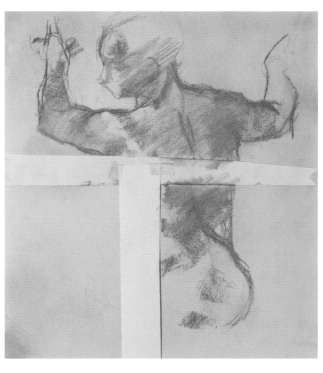

5

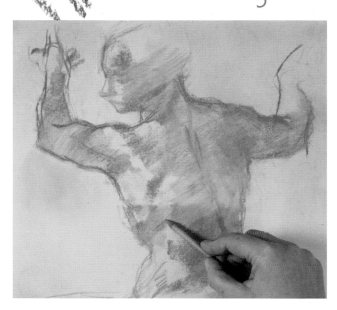

6

4. Make a vertical divider with another strip of paper. This will help you block in the model without drawing construction lines or grids, which would be difficult to remove with an eraser.

5. Dip a blending stump in sanguine pigment and hold it sideways to blend the shading of the back. Work on eliminating the still visible signs of the strips of paper.

6. Now use a pencil, which will give you a firmer, more precise line for the outlines of the face and arms. Darken the shadows on these parts of the body, taking care not to smear the drawing with your hand. In the video we show you how to proceed.

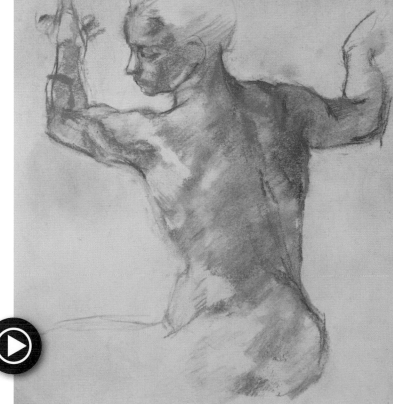

7

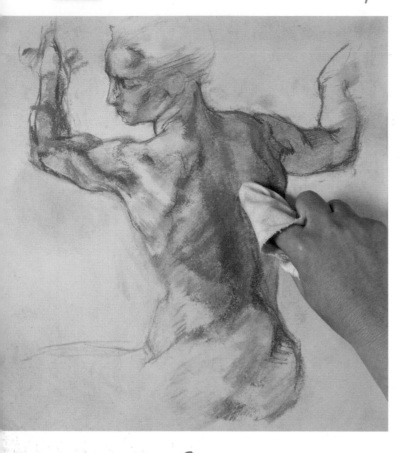

An Athlete's Body

Michelangelo used a male model to recreate the body of the Libyan Sibyl, which explains her great size and prominent musculature. All the female figures in the vault of the Sistine Chapel have athletic bodies but with feminine attributes. In this phase of the work, you should pay close attention to the modeling of the anatomy, adding volume to the prominent muscles with a combination of very dark and intense shadows with erasing and highlights, created with a rag and a kneaded eraser. You should have a selection of several sanguine pencils of various tones, including ones that are darker than the sticks used for the initial sketch.

7. As you darken the flesh tones on the back, you should pull out the lightest areas with a clean rag. The same rag should be used for wiping the areas where the pigment saturates the surface of the paper to create middle tones. Developing smooth transitions of light is very important in visually explaining the surface relief.

8. Use a sanguine pencil in a darker red color to go over the outlines, detail the facial features, and reinforce the mass of the left arm. The line work is more fluid on the right hand, giving it more of a sketched look.

9. To model the muscles, draw lines that follow the forms and curves of the body. Apply enough pressure to create well-defined lines. The most prominent areas should be made a lighter color to create a dimensional effect. Watch the video to see how increased pressure is applied, and how the outline of the figure is treated.

8

9

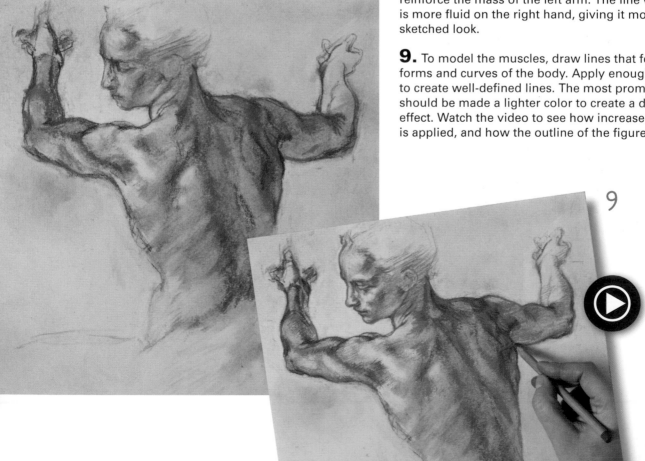

10

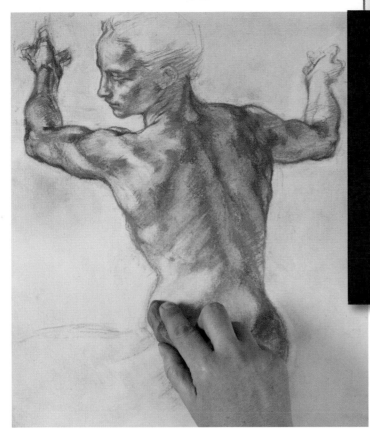

The gesture and the forms should be getting stronger. Emphasize the description of the arm muscles and highlight the hollows of the shoulder blades and spine.

11

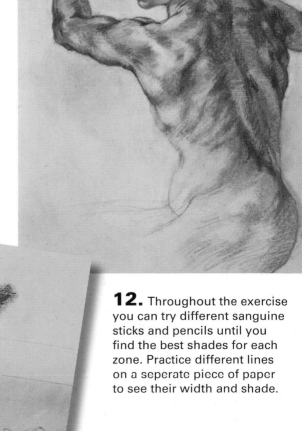

10. Use your eraser on the left shoulder and on the belly with the kneaded eraser.

11. Once the body is close to being formatted you can work on the details and compare each area to the original model. It is necessary to increase the size of the arms and hands, and a new outline will help make them bigger.

12

12. Throughout the exercise you can try different sanguine sticks and pencils until you find the best shades for each zone. Practice different lines on a seperate piece of paper to see their width and shade.

Modeling the Muscles

The meticulous reproduction of the muscles and tendons is based on the personal observation of the great Renaissance geniuses. The intensity with which Michelangelo worked on human anatomy was intimately tied to his study of classical sculpture. The ideal models were figures like this one that displayed muscular bodies in twisting poses and violent motion. Successfully modeling the muscles of the Sibyl is necessary for achieving a perfect copy. In this final phase of the drawing, you will use sanguine pencils of a darker tone, and even a bistre pencil for darkening some outlines.

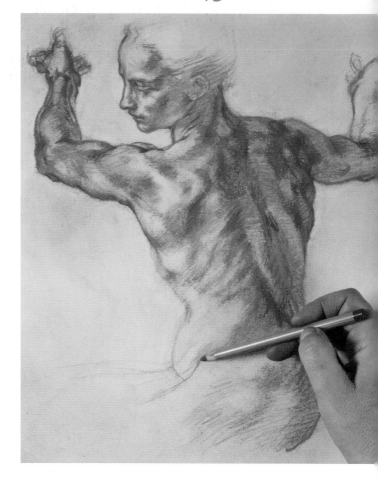

13

13. The harder sanguine pencils maintain their sharp points much longer. They are used for drawing parallel hatch lines in the hair and in the hip area, thus giving the drawing an unfinished aspect, without precise edges.

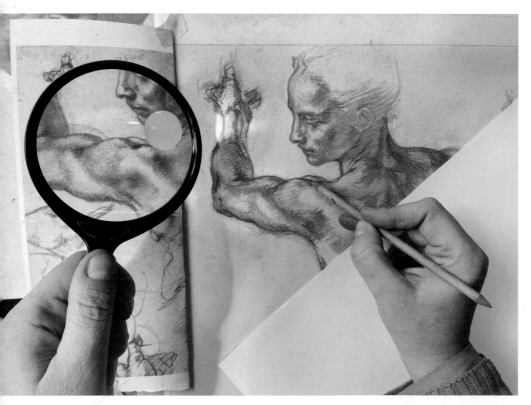

UNTIL THE FINAL DETAIL

The strong desire for the perfect copy can cause many copyists to take great pains with even the tiniest detail. In this case, it is very important to have good light, well-sharpened pencils, and a magnifying glass to enlarge the more indistinct areas so you can see the direction of the lines and pressure the artist applied. Therefore, a great amount of patience is required to work on the small details in a slow, sure, and accurate manner.

Finally, increase the overall shading. The outlines of the figure and the darkest shadows should be reinforced with a very light application of bistre.

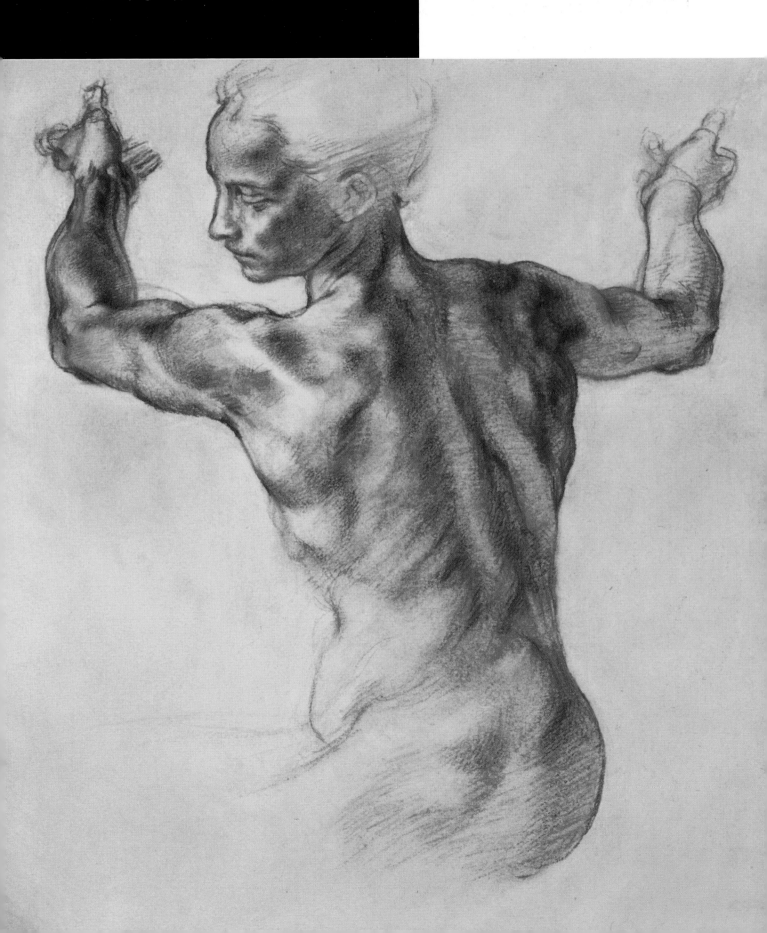

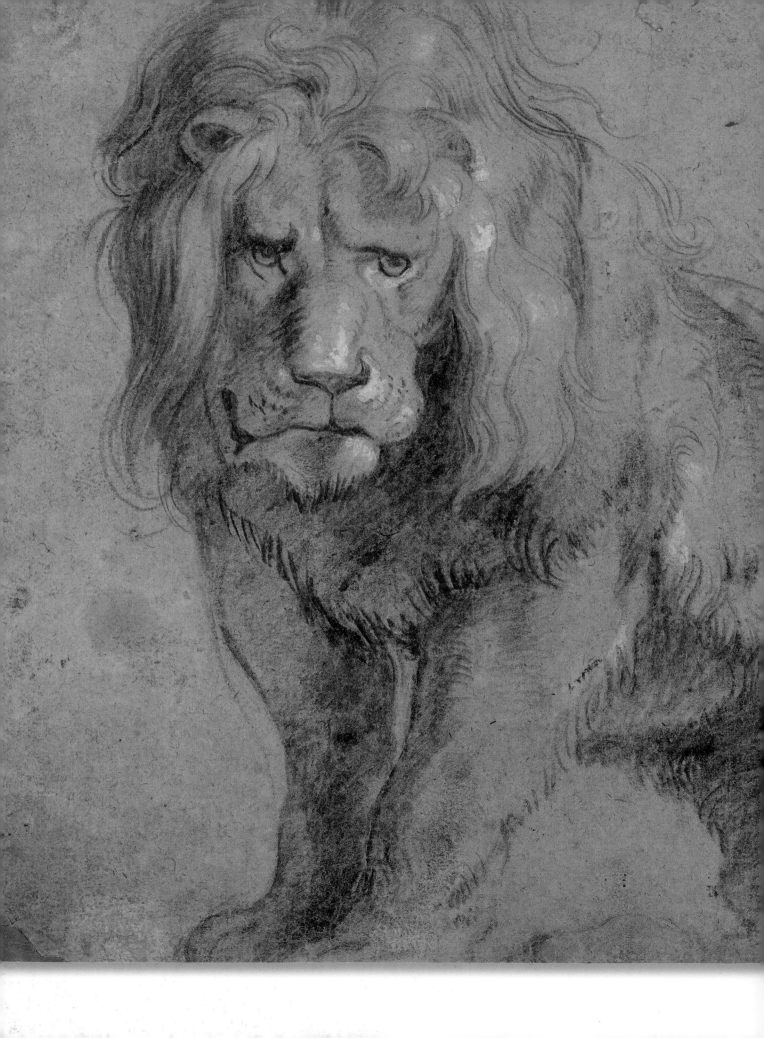

Peter Paul Rubens, *Lion*, circa 1613–1615. Black chalk and ochre, with white gouache highlights, 10 × 11⅛ inches (25.2 × 28.3 cm). National Gallery of Art, Washington, DC.

Study for a Lion
by **Rubens**

Peter Paul Rubens (1577–1640) used this and other drawings of lions as preliminary studies for his painting *Daniel in the Lion's Den*. More specifically, this work is a study for one of the lions that is in the background of the composition. The lion is erect, calm, and has a dominating stare. However, the lifelessness of the drawing makes many specialists think that Rubens used a bronze sculpture rather than a live animal as a model. The strong outline, applied with dark black chalk that seems to enclose the form, supports the theory that this must be a study of a static figure. Even the final application of gouache highlights point to this possibility. Rubens' drawing was done with only chalk, but here we will use charcoal as well as chalk. This will make the work easier and allow us to make corrections, especially during the first phases of the drawing.

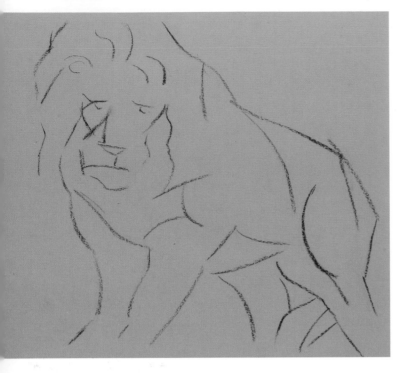

1

From Charcoal to Chalk

Rubens had the sufficient mastery to approach the drawing of the lion directly with black chalk, but it is likely that many copyists would prefer to draw with charcoal, which allows the possibility of erasing and correcting whenever necessary. For this reason, we will begin the blocking in stage of the drawing with charcoal. As with any copy, capturing the shape is fundamental to achieving a good likeness. Once the drawing has been clearly defined we can begin to add more detail lines, especially on the lion's fur, with a black chalk pencil. For a support, we are using a beige tone sheet of Canson paper. This exercise was done by Mireia Cifuentes.

1. The first marks made on the paper with the charcoal stick are, without a doubt, the most complicated, although they seem very simple. It is a matter of blocking in the approximate shape of the lion with very simple lines. The negative spaces will help in determining the outline.

2. Use a clean rag to erase the previous lines, which will not disappear completely but be quite faint. They will be useful for guiding the new lines so they will follow the structure of the initial sketch.

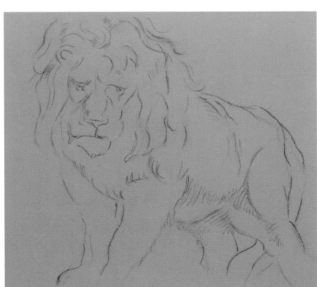

2

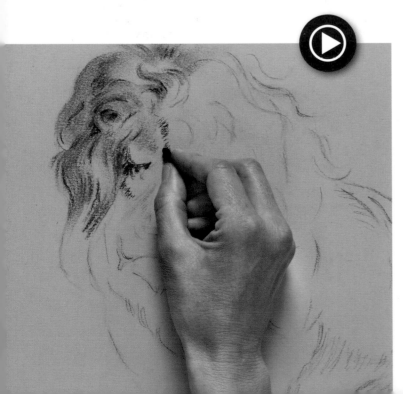

3. The structural lines should be very light so they can be integrated in the first pass at shading with charcoal. Darken the area with the blunt tip of the stick and then blend the line with your hand. Begin suggesting the animal's fur with a few curved and undulating lines. Watch the development of the drawing in the following steps on the video.

3

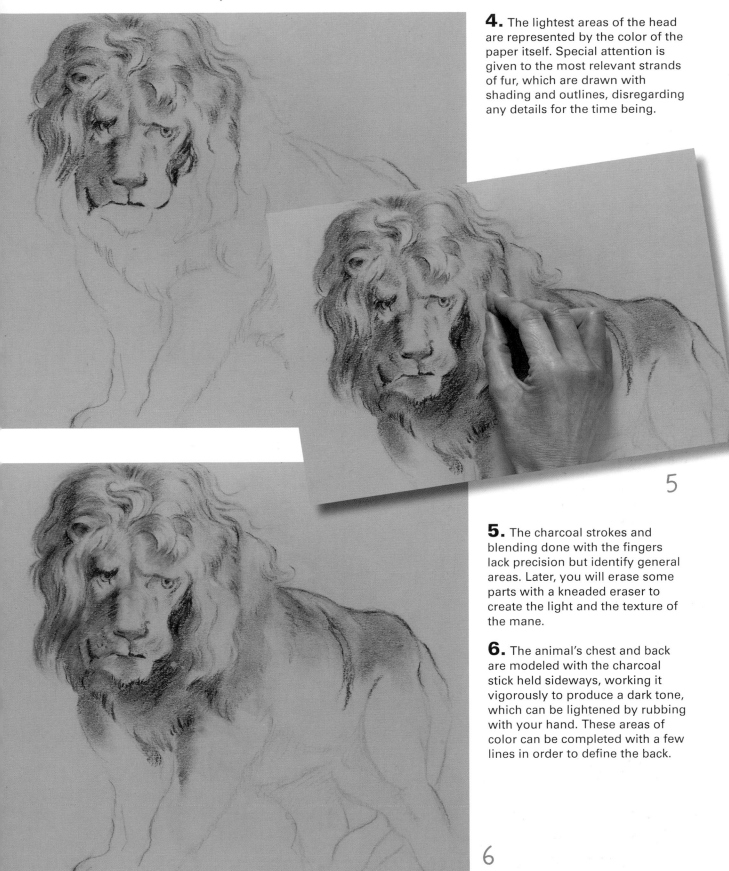

4. The lightest areas of the head are represented by the color of the paper itself. Special attention is given to the most relevant strands of fur, which are drawn with shading and outlines, disregarding any details for the time being.

5. The charcoal strokes and blending done with the fingers lack precision but identify general areas. Later, you will erase some parts with a kneaded eraser to create the light and the texture of the mane.

6. The animal's chest and back are modeled with the charcoal stick held sideways, working it vigorously to produce a dark tone, which can be lightened by rubbing with your hand. These areas of color can be completed with a few lines in order to define the back.

Working the Volume in the Fur

No painter embodies the Baroque better than Rubens, with a style characterized by dramatic movement and free, fluid strokes, which can be seen in the animal's fur. For this reason, the copyist has to pay special attention to the texture to make sure it is properly reproduced, using short strokes made with a thin charcoal stick and combining them with longer strokes for the shaded areas intertwined within the strands of fur. It is important to concentrate on the feeling of volume, as well as on the direction suggested by the way the hair falls. The dark tones are worked gradually so the grays can work together, as the heaviest values placed in the correct area.

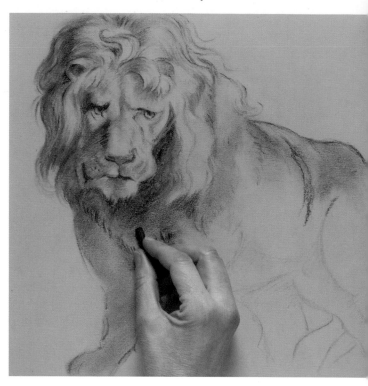

7

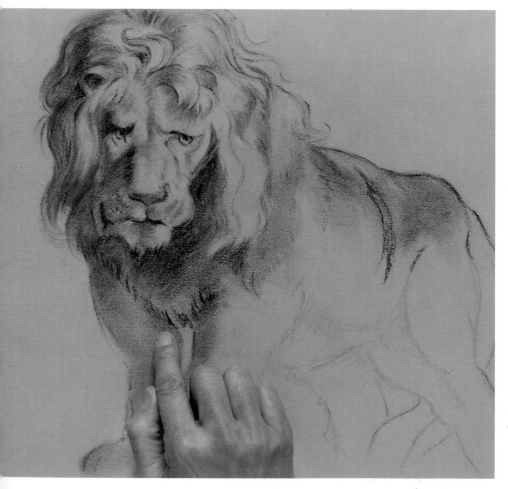

8

7. The head of the lion is beginning to resemble the model. The dark tones that create the volume are drawn with a charcoal stick approximately 1 inch (2 cm) long. The intensity of the shadow underneath the head is an important contrast against the bright areas of the face and the different planes of the lion.

8. The lines and marks that are made by dragging the charcoal stick can be blended with the fingertips, forming gradations and soft gray transitions. Press gently. These blended areas are the ideal complement to the lines made with chalk.

9. Now you'll use the chalk pencil, first to build up the shading of the front legs, then to better define the texture of the fur. Its fine point is used for touching up and for the small details of the animal's features.

10

9

10. Working with charcoal or chalk tends to smear adjacent areas with the pigment dust, which is why it is important to clean up every now and then with the kneaded eraser. This also creates lines that help define the texture of the hair—the fur of the lion is lightened with soft lines created with the eraser.

RUBBING WITH THE HAND

The drawing order is as follows: begin at the upper left side and continue diagonally in a downward direction; this prevents rubbing the area that has already been worked with the hand. The video shows how blending and erasing are fundamental to creating the contours.

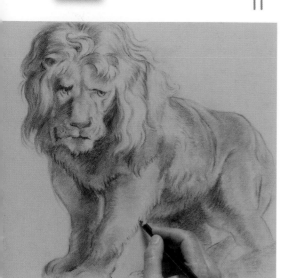

11

Final Touches

For an artist like Rubens, the drawing had a specific function in the production of his works. Although his pencil portraits were his preliminary sketches, they can be considered independent masterpieces because of their quality. As such, the master would apply certain finishes that enriched their beauty. His love for detail, for small touches of color, or even highlights that gave the piece greater vitality was not typical of the sketching process. In this last phase of the work, we will incorporate a yellow ochre color chalk and white gouache for the background.

12

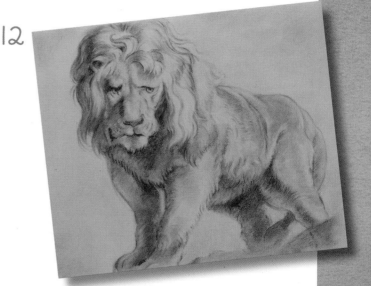

11. The charcoal work is finished. Now we will focus on the small details, the more delicate lines made with black chalk pencil. Before we begin, it is important to spray the drawing with a fixative to preserve the charcoal lines so you are able to work more freely.

12. Use the black chalk pencil to draw the interior outlines of the legs with a rounded, curved crosshatching method. Then draw contour lines as additional touching up before finishing the drawing of the animal.

13. Using a yellow ochre chalk pencil, color the background by dragging it on its flat side to cover the area quickly, rubbing it afterwards to blend it with the color of the paper.

14. With a thin brush and a small amount of white gouache, touch up the body of the animal to create a few white areas. Rubens used to apply small highlights of whitish gray to give it a more lively appearance.

13

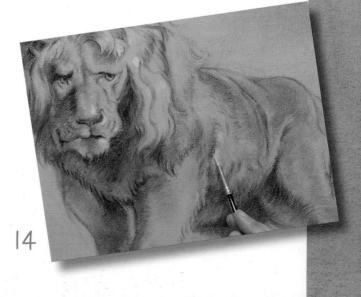

14

In the finished piece, the artist's great interest in representing felines is evident, as they are common in some of his most important work. He portrayed them with a naturalist's interest, referring to zoology books of the time. The steady line and the strength of the shading are distinctive features of this copy as well.

Although Rubens was more famous for his paintings than for his drawings, the experts consider him one of the most imaginative drawing artists in history. His subjects range from biblical scenes to portraits of nobility.

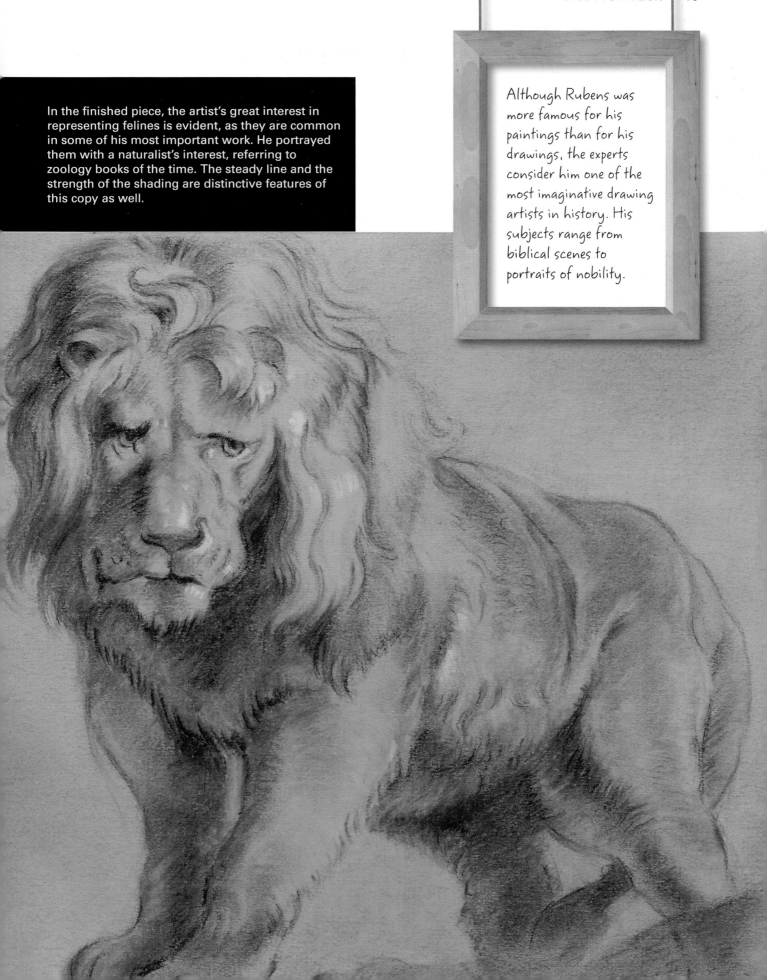

Portrait of a Bearded Old Man by Rembrandt

Rembrandt Harmenszoon van Rijn, Bearded Old Man Seated in a Chair, circa 1631. Sanguine on paper, 10 × 6¾ inches (25 × 17 cm), Private collection New York, USA

Portraits are very popular among the work by Rembrandt Harmenszoon van Rijn (1606–1669). His most frequent models were not the nobility or the high bourgeoisie but regular people, street people, and the neighbors who posed spontaneously in his studio. This may be why his drawings look so natural and reflect great humanity. The work that is presented here is the portrait of an elderly man that he had the opportunity to draw repeatedly, in different poses and from various vantage points in a single session. It is a drawing done with sanguine and represents an old man seated, relaxed. It was composed with just a few decisive lines combined with strong shading, dense areas of color that give body and solidity to the figure and that exhibit the famous command of the light attributed to the author.

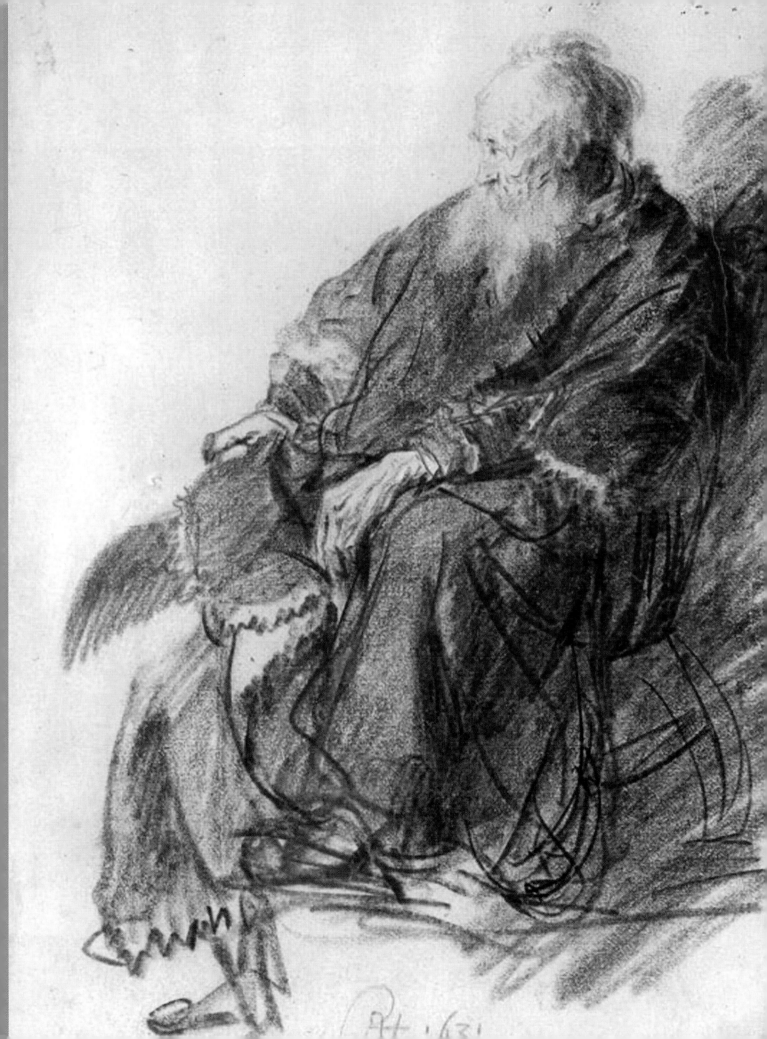

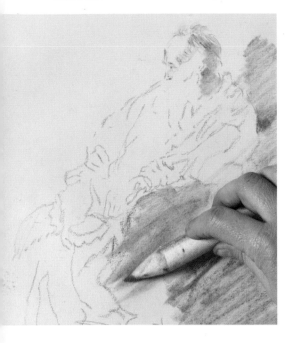

A Sketch-Like Technique

Rembrandt made light the great protagonist of his work, thanks to generous and densely-applied shading that gave a sketch-like appearance to his drawings. Good copyists have to adapt their drawing style to the artist that they want to emulate. For that reason, in this exercise we are not proposing a technique using lines, but only some light shading with a blending stump, which is later defined with shading applied with sanguine. The kneaded eraser is indispensable to create areas where light hits and to add more definition to the contour of the figure. In this exercise, we will use two tones of sanguine and a chalk bistre pencil. Drawing by Mercedes Gaspar.

1. In this sketch-like drawing, the first shading and strokes are applied with the tip of the blending stump covered with sanguine pigment. To do this, rub the stick over an abrasive surface, then collect the dust on the tip of the blending stump.

2. Hold the blending stump at an angle and move it in a decisive zigzag motion. First cover the main areas of shadow with a soft darkening and sanguine blend. Leave the hands and the face blank. Watch in the video how a blending stump covered with sanguine can also be used to draw.

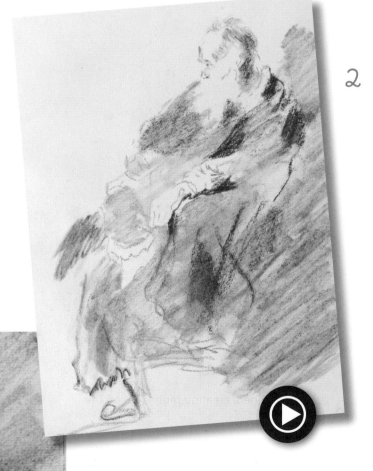

3. The shading created with the blending stump is complemented with more shading applied with the sanguine stick, which is more orange in color. Each new addition of color is modeled with a smaller blending stump to better conform their shape to the folds and contours of the clothing.

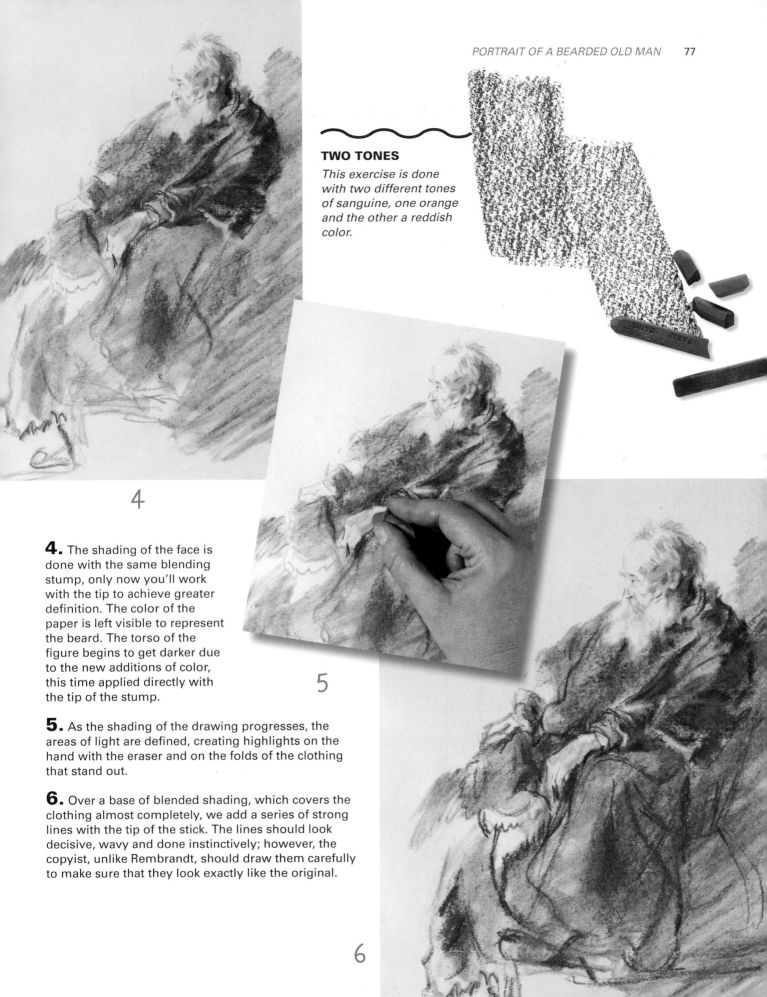

TWO TONES

This exercise is done with two different tones of sanguine, one orange and the other a reddish color.

4

4. The shading of the face is done with the same blending stump, only now you'll work with the tip to achieve greater definition. The color of the paper is left visible to represent the beard. The torso of the figure begins to get darker due to the new additions of color, this time applied directly with the tip of the stump.

5

5. As the shading of the drawing progresses, the areas of light are defined, creating highlights on the hand with the eraser and on the folds of the clothing that stand out.

6. Over a base of blended shading, which covers the clothing almost completely, we add a series of strong lines with the tip of the stick. The lines should look decisive, wavy and done instinctively; however, the copyist, unlike Rembrandt, should draw them carefully to make sure that they look exactly like the original.

6

The Copyist Should Work Slowly

7

The particular way in which models are interpreted with sketched lines and blended shading is the reason why Rembrandt has become a very revered master among contemporary artists. Another aspect that is worth mentioning is that most of his preliminary sketches, unlike those of many other artists, constitute a work of art in their own right, with no other purpose than the drawing itself. This means that even experienced copyists should work slowly, analyzing and comparing the placement and intensity of each line. The copied drawings must appear fresh and spontaneous, and they must convey the same sketch-like spirit of the reference work from which they are drawing their inspiration.

7. The body of the chair is drawn, using a more reddish sanguine stick than the previous one. This oxidized color derives from iron, and its intensity depends on the proportion of pigment mixed with the clay—the higher the content of pigment, the stronger the color.

8

8. The last applications are done with a bistre pencil, a dark earth tone. The contours in the most shaded areas are defined, on the hand and on the back. Also, a few expressive lines are added on the base of the figure. Watch in the video how in this last phase the sanguine lines are more linear.

CONTROLLING THE LINE

There are lead holders or square chalk holders that are very useful to hold small stick pieces. They can also help control the lines.

Before finishing the work, use the eraser to clean the outline of the figure, opening with it a few areas of light on its left half. The purpose of this and other drawings by Rembrandt was not for the practice of the hand but for the training of the eye. Its contribution to the painting genre coincides with what the historians call the Dutch Golden Age.

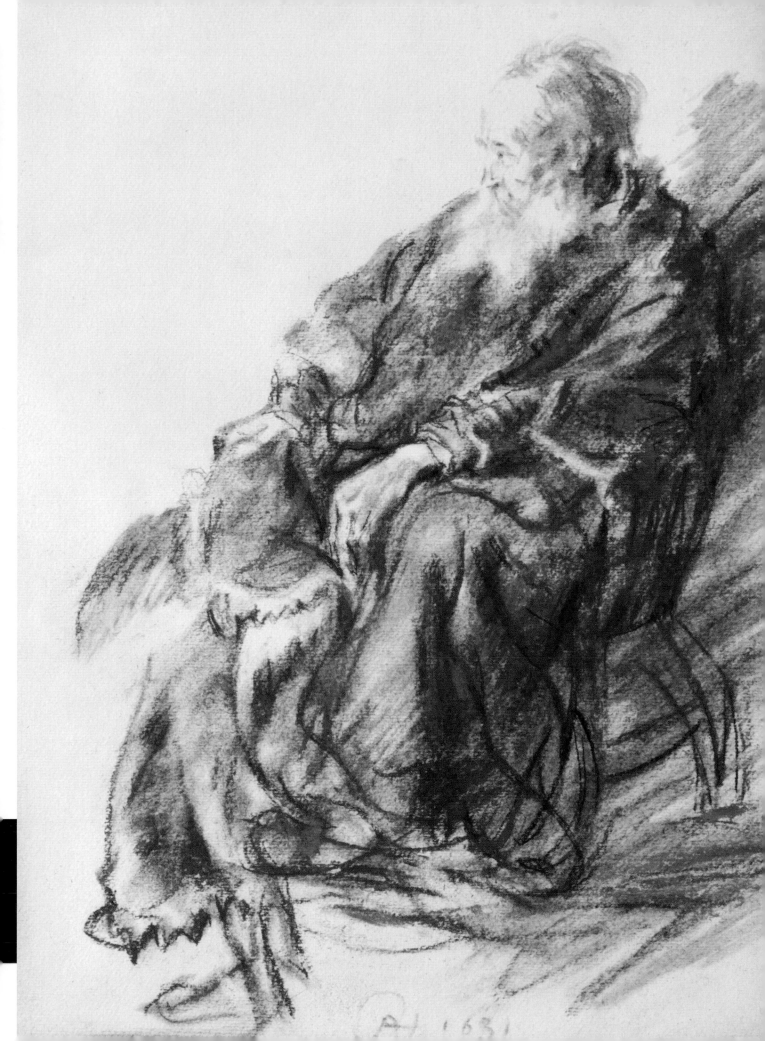

Jean-Honoré Fragonard (1732–1806), together with Watteau and Chardon, was one of the most popular French painters of the 18th century and the one who best interpreted the Rococo style, also known as Galant painting. During his stay in the Mancini Palace, in Rome, the headquarters of the French Academy, he made many copies, drawings as well as paintings, of the great masters of the past. But it was also there, in the Italian capital, where he rebelled against the conventions of the Academy and began to draw and paint directly from nature, not common among the artists of the time. In the presence of nature and of the ruins of ancient Rome, he produced admirable studies of parks and gardens drawn with sanguine, like the one presented in this exercise. In his work, we can see the influence of the Italian and Dutch masters, although the artist maintains his style, of short, vigorous strokes. To put this method in practice, you will need a well-sharpened sanguine pencil and a fine grain paper. Here, we will use white to enhance the contrast between the background and the lines.

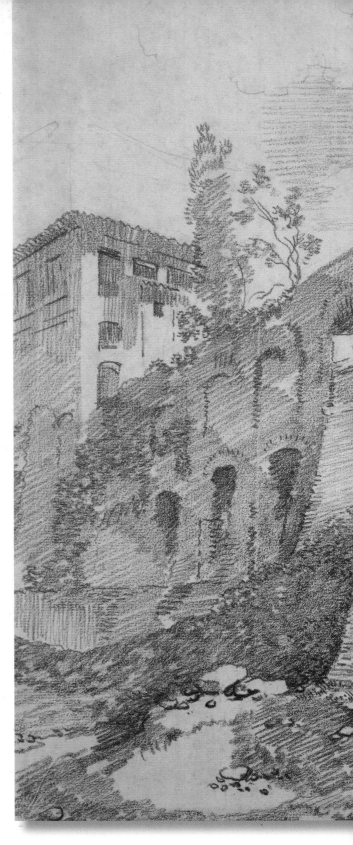

Jean-Honoré Fragonard, *Ruins of an Imperial Palace*, Rome, 1759. Sanguine on tan paper, 13¼ × 18¾ inches (33.5 × 47.6 cm). J. Paul Getty Museum, Los Angeles

A Garden

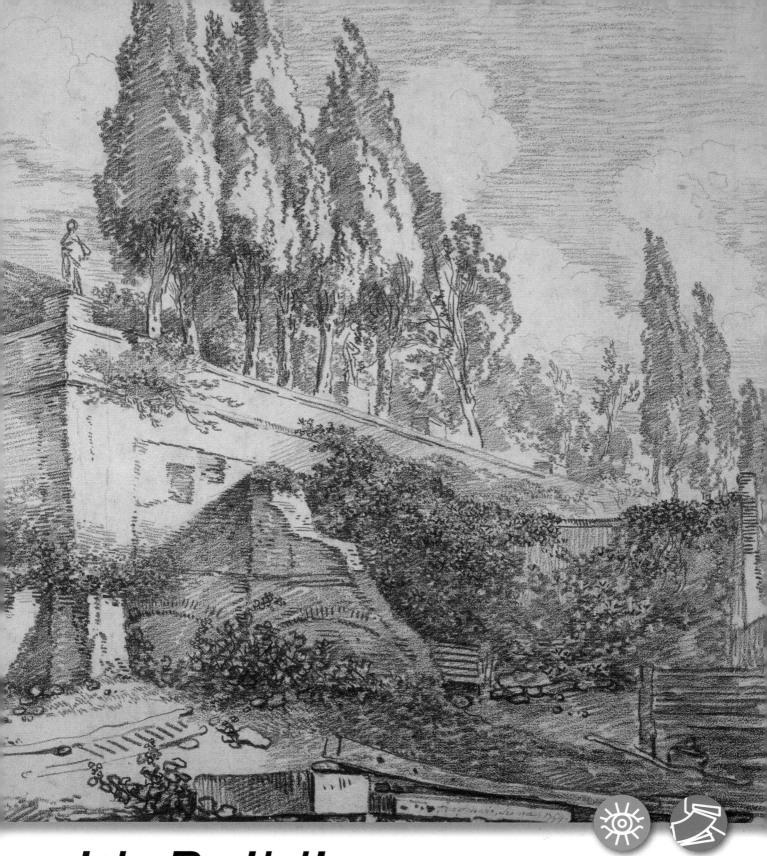

with Buildings
by **Fragonard**

First Charcoal, Then Sanguine

The sanguine technique was very popular with many artists, among them Fragonard, because it is easy to work with it and because of its vibrant red color, which was thought to be much warmer and expressive than black related pigments.

Before you start to draw with decisive sanguine lines, it is a good idea to identify the main elements. We use charcoal for the layout because the lines are softer than sanguine and they can be erased easily with a rag or even with a kneaded eraser, making them invisible at the advanced stages of the drawing. The very light lines can be concealed with shading and the somewhat dark sanguine lines. Exercise by Mireia Cifuentes.

1. The elements that make up the landscape are marked with the charcoal stick. The lines are simplified and extremely light, almost imperceptible, drawn to block in the perspective of the building and the most prominent trees.

2. These first lines are reinforced with new lines to detail the architectural highlights, the openings of the building, and the shapes of the first masses of vegetation. The work consists strictly of lines; no light shading or blending is involved.

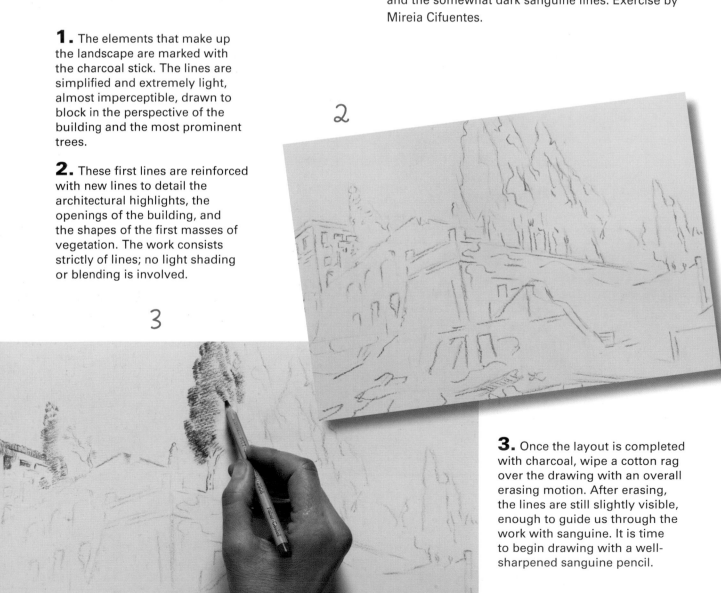

3. Once the layout is completed with charcoal, wipe a cotton rag over the drawing with an overall erasing motion. After erasing, the lines are still slightly visible, enough to guide us through the work with sanguine. It is time to begin drawing with a well-sharpened sanguine pencil.

4. The first lines are light and parallel to the walls of the façades. To mark the windows, press a little harder on the pencil.

4

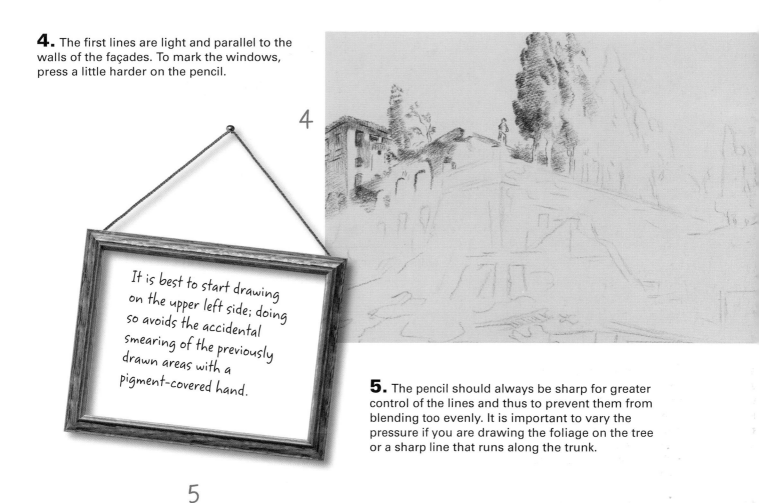

It is best to start drawing on the upper left side; doing so avoids the accidental smearing of the previously drawn areas with a pigment-covered hand.

5. The pencil should always be sharp for greater control of the lines and thus to prevent them from blending too evenly. It is important to vary the pressure if you are drawing the foliage on the tree or a sharp line that runs along the trunk.

5

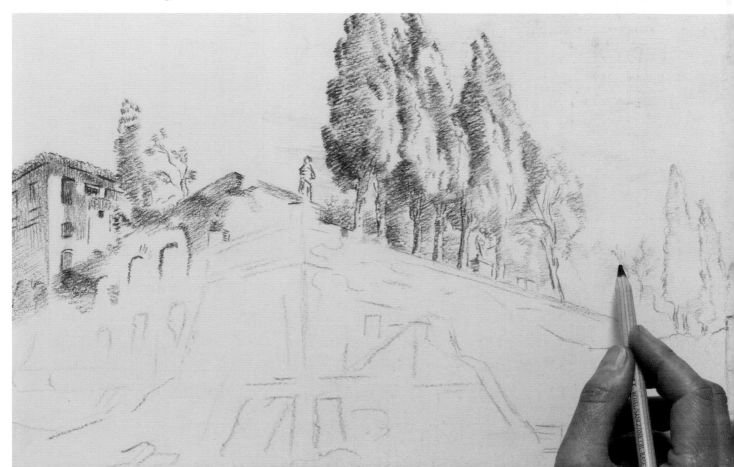

Short and Vibrant Lines

Fragonard is one of the best representatives of drawing of the 18th century. His spirited, graceful style and his very vivid sensibility allowed him to create drawings of great visual impact with brilliant light effects on the vegetation and architecture, always dominated by imposing cypress trees. His strokes are short and vibrant and leave spaces in between to allow the color of the paper to breathe through; with this approach the sanguine lines add life to the subject. It is important to pay attention to the constant changes in the direction and the character of each line, which will vary according to the surface that is being described. Make sure that the tip of the sanguine pencil is always well sharpened to prevent lines from fading.

6

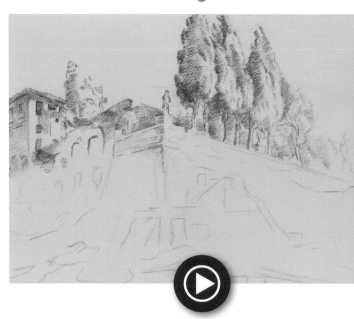

6. On the sky, the lines are just soft strokes drawn with the sharp pencil tip. The pressure variation of the line is more visible in the treetops. The branches are drawn with scribbled lines over the medium tone shading. Watch the video to see the importance of how the hatching is applied.

7. The walls of the building are drawn with two tones of shading: a medium, general tone on the walls and a darker one to represent the hollow areas, arches and openings. In the more illuminated areas, leave larger spaces between the crosshatched lines to allow the paper to show through.

7

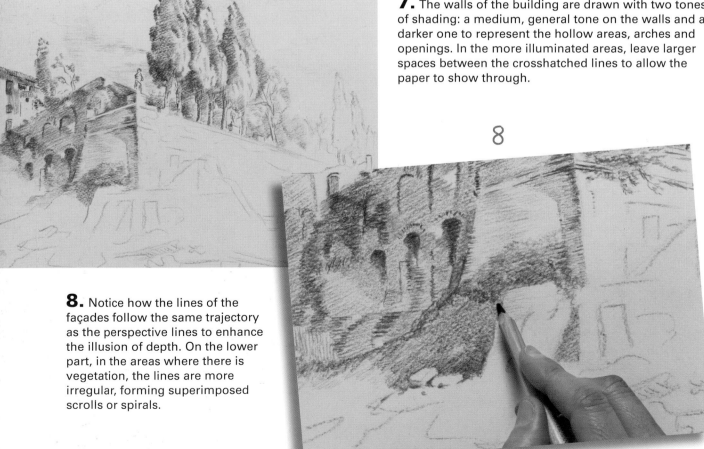

8

8. Notice how the lines of the façades follow the same trajectory as the perspective lines to enhance the illusion of depth. On the lower part, in the areas where there is vegetation, the lines are more irregular, forming superimposed scrolls or spirals.

9

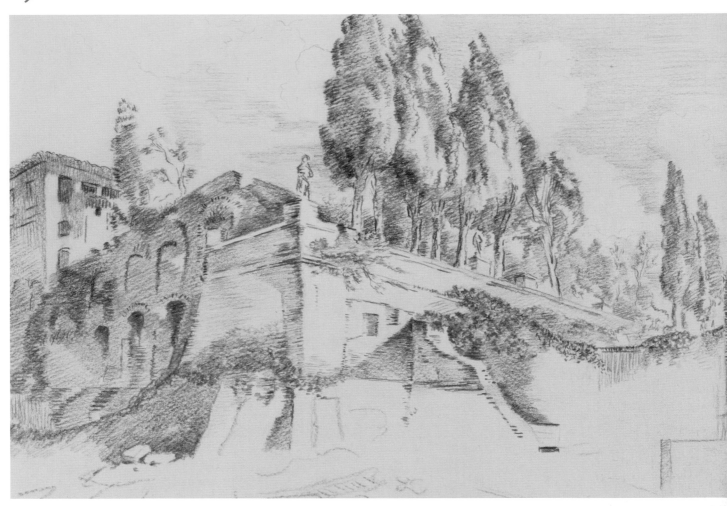

9. Use the same approach on the right half of the composition, although the presence of the white of the paper here is more pronounced because it represents the façade directly illuminated by sunlight. The buttresses are drawn with short and sharp lines, while the vegetation is shaded, more or less uniform, with sharp tiny scribbled lines.

10. Moving from top to bottom prevents the hand from rubbing and smearing the existing lines. Both the lightest and extensively shaded areas, applied with the side of the pencil point, are completed with textured effects drawn by applying more pressure on the paper with the sharpened pencil point.

10

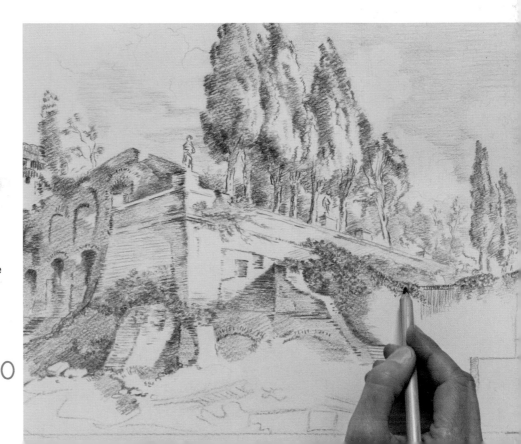

Contrasts, Finishes and the Direction of the Lines

In this drawing, the essential qualities of work done with sanguine pencil are the highlights, the finishes in the vegetation, and the texture of the stones, which makes this technique ideal for nature studies. Fragonard, undoubtedly, drew quickly and freely; however, copyists should work very slowly, very carefully, and pay attention to the finishes and the direction of each line. As you approach the end of the exercise, the stroke should be more decisive. It is important to highlight and underline the effects of light and shade, so they play off each other.

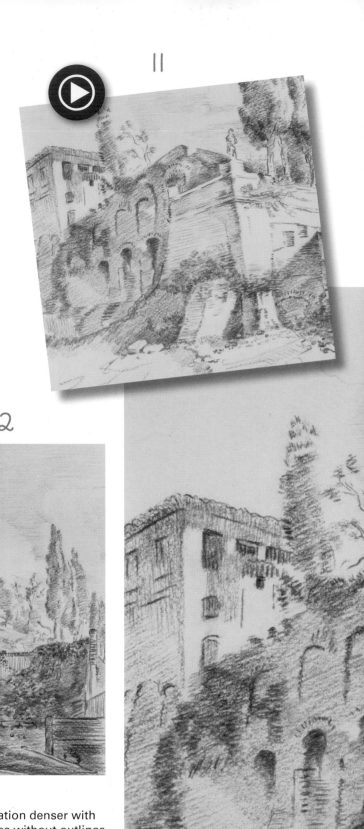

11

12

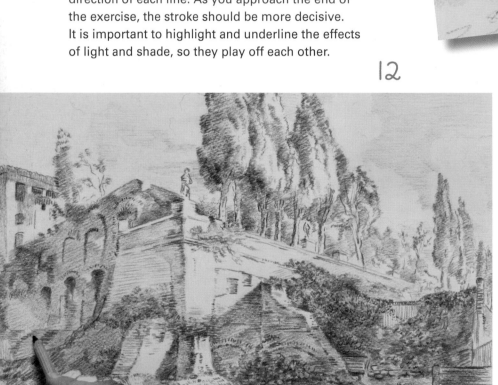

11. The foreground is worked while making the vegetation denser with new crosshatched lines. The vegetation, a mass of strokes without outlines and devoid of details, enhances the power of the work. In the video, watch how the direction and quality of the lines vary depending on the surface being depicted.

12. The shaded areas are darkened by overlaying very short parallel hatch lines. On the nearby plants, use light scribbled lines. Do not outline the shaded areas with solid lines; only the stones will be contoured with lines.

SANGUINE TONES

The use of sanguine became popular beyond the theme of landscapes, and very sought after for the representation of the human figure because it produces tonalities that are very close to the color of skin.

In the finished work, we can see how the dynamic feeling has been recreated with broken lines and varied pressure, as if it were a collection of textures or marks. The only difference from the previous step is the adjustment of the final tones, which is achieved by making the lines darker in the more shaded areas of the composition.

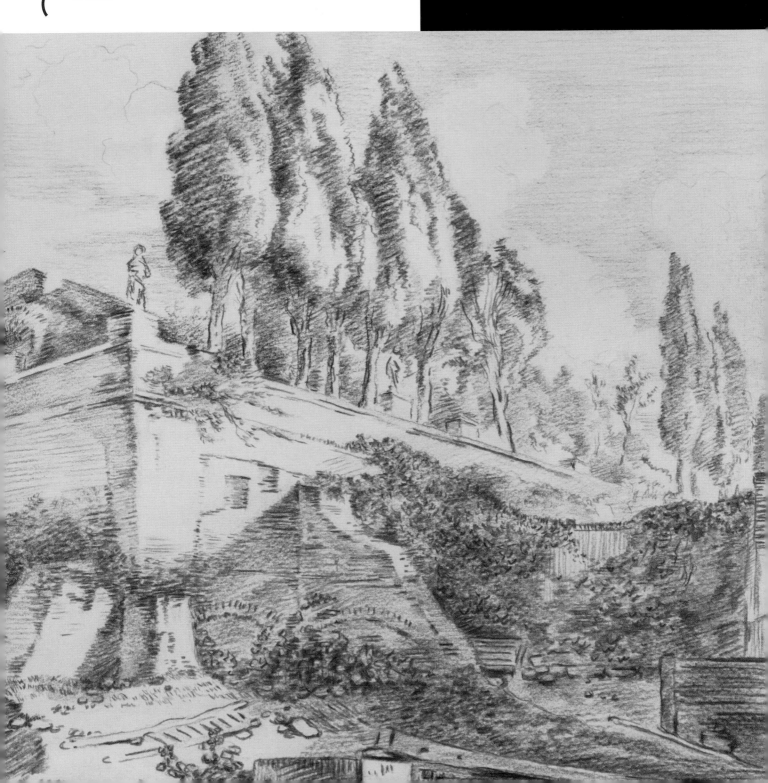

Caspar David Friedrich, *Tumulus Near the Sea*, circa 1806-1807. Sepia wash and graphite pencil on vellum paper, 25¹/₂ × 37³/₄ inches (64.5 × 96 cm). Klassik Seimar, Weimar, Germany.

A Landscape with Trees

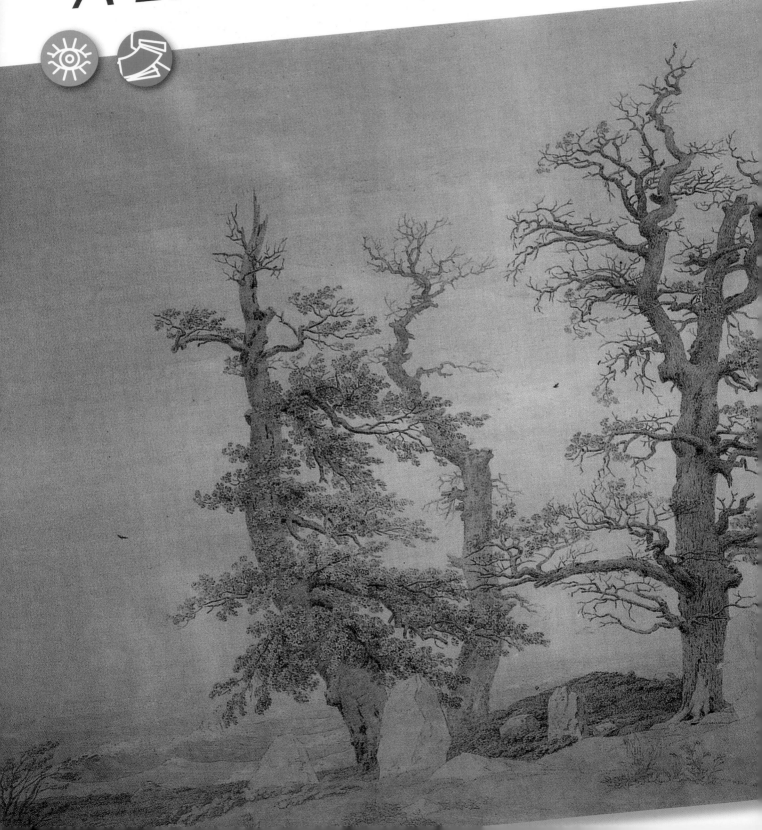

by **Friedrich**

Caspar David Friedrich (1774–1840) is one of the most significant artists of the early Romantic Movement. Nature was for him not only an opportunity for artistic exploration, but also a context in which to experience the omnipresence of Divinity. For this reason, many of his works depict lonely landscapes that convey intense peace, with a clear spiritual conviction. In his work, trees were a key component to the point where they became an obsession. In this artistic recreation, reality is portrayed in such a way that a tree could be configured with several different trees drawn previously from nature in a sort of compositional approach. He was extremely frugal in his work because he often reused his studies from nature to create new compositions over them. The work presented here is a clear example of that. To accomplish this, Friedrich adopted a special drawing technique that consisted of applying sepia color washes on paper, then used shading and texture with graphite pencils later to address form. With the repeated application of pencil lines, both techniques blended into one, giving the finish a greater volumetric appearance. Let's see how it is done.

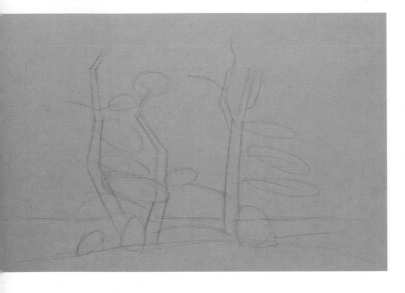

From Line to Tone with Washes

After a very geometric initial blocking in, the shapes of the trees are formed with very thin pencil lines. The irregular contour lines of the enormous trunks and the framework of the entangled branches are represented with abrupt changes of direction for the stems and branches. It is important to pay attention to each change. The tree should be literally "photographed." In their basic appearance, the three trees are drawn very similarly. When it came to drawing the framework of the tree branches, Friedrich was very exact in his compositions because it represented the species of tree in question, not any other. The different tonal gradations, in which no brushstroke marks are perceived, are achieved with layers of very diluted sepia washes applied with very thin brushes. This exercise was done by Gabriel Martín.

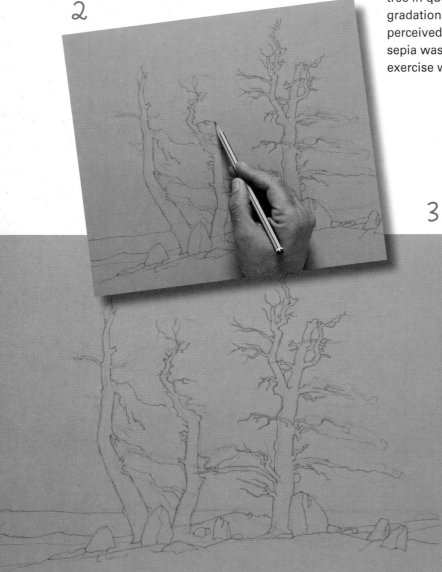

1. To block in the trees, we use an HB graphite pencil on a sheet of ochre Canson paper. First, we mark the position of each tree with geometric, quick sketch-like lines.

2. Once satisfied with the initial structure, the lines are lightly erased with an eraser. The lines should be visible enough to draw the trunks with a 2B pencil, although this time the lines will be more fragmented and strong, more in line with the winding nature of the model.

3. In the first phase, the composition is resolved with a very precise linear drawing that outlines the forms of the stones and trunks, as well as the main branches. It is important to pay attention to each shape and highlight so that it closely resembles the model.

4. After planning the main structure, we focus our attention on the smaller systems of branches and leaves. The approach does not change. With a very sharp 2B graphite pencil, work each area until it looks like the original model.

LINE PRECISION

Drawing with very detailed and precise lines like the ones in this exercise require the pencils to be well sharpened at all times.

4

5. Dilute a small amount of sepia watercolor in a well until the wash is very light and clear. Cover the background of the landscape, the trunks, the thicker branches, and the system of tree leaves and foliage with it. Right away, the color may appear very dark, but will become lighter when it dries.

5

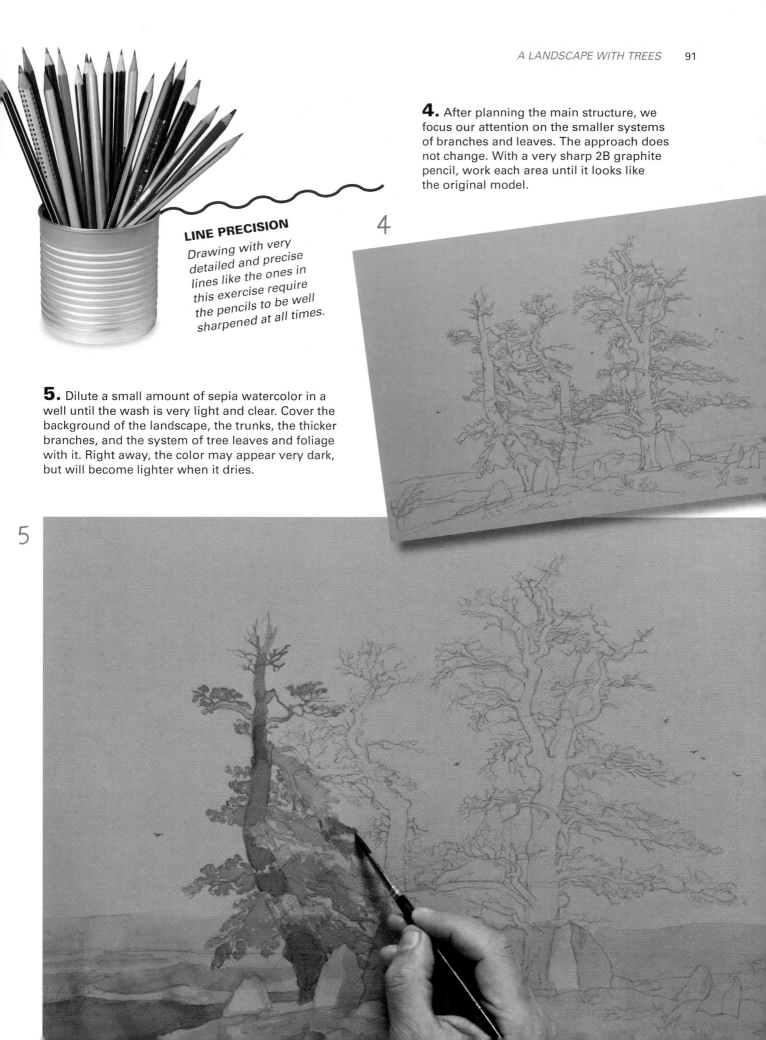

6

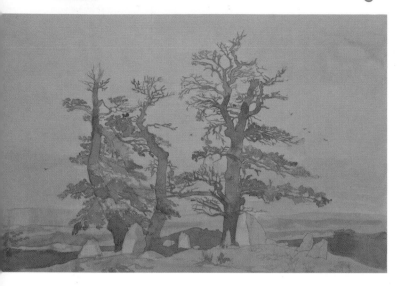

Mixed Shading with Wash and Graphite

The shading is created by superimposing two sepia color watercolor washes. The first wash provides an overall tone to the trees and the grass beside them, and the second is applied with a dry brush on several prominent branches as well as the shaded half of the tree. The final adjustments are done with a 4B graphite pencil: superimposing soft, shaded lines that blend with the washes underneath, darkening its value to create contrast.

6. In this phase of the drawing, we can appreciate the result of a first uniform wash of sepia paint. There are barely any transition or brush marks. The wash is applied even more diluted in the seascape background.

7

8

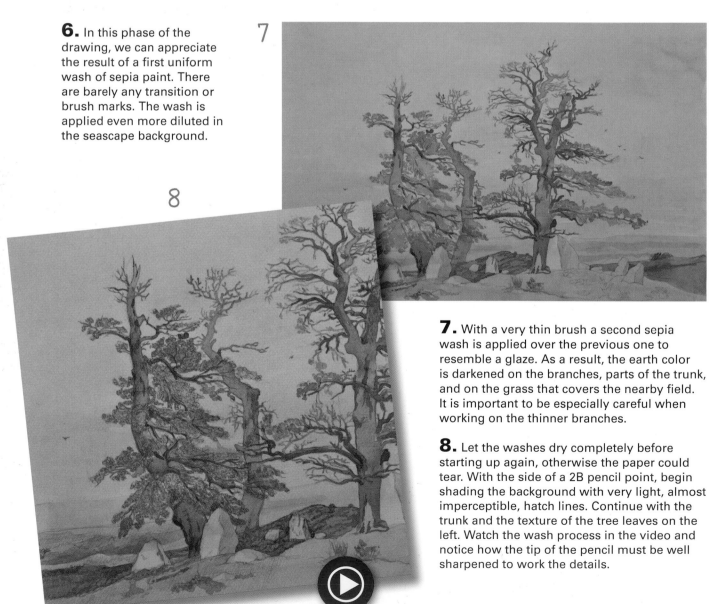

7. With a very thin brush a second sepia wash is applied over the previous one to resemble a glaze. As a result, the earth color is darkened on the branches, parts of the trunk, and on the grass that covers the nearby field. It is important to be especially careful when working on the thinner branches.

8. Let the washes dry completely before starting up again, otherwise the paper could tear. With the side of a 2B pencil point, begin shading the background with very light, almost imperceptible, hatch lines. Continue with the trunk and the texture of the tree leaves on the left. Watch the wash process in the video and notice how the tip of the pencil must be well sharpened to work the details.

9. The tree leaves are finalized with a series of thin, strong hatch lines that form small, tight, yet spontaneous scrolls. With a graphite pencil, darken the branches that were shaded with washes and draw other small branches. The key to everything is to be patient and work thoroughly.

9

It is important to pay special attention to the texture of the tree bark, which is drawn with perpendicular short, fragmented lines of irregular thickness and intensity.

10. The placement of a few plants and stones in the foreground is done with more or less structured linear strokes.

10

Creating the Details

Friedrich's work is based on details; he approached every aspect of the landscape meticulously. His drawings encompass a delicate beauty, portrayed with small lines drawn with very sharp graphite pencils. In relation to the rest of the tree, which is the main element of the drawing, it is important not to neglect the treatment of the stones or the small plants, and to avoid any rigid intervention. The aim should be to synthesize the most characteristic elements with short, precise lines. In this last phase, the work will progress very slowly because it is important to create the texture of each area well. The small details, as well as the larger illuminated areas, are drawn with pencils in delicate tones and dark shadows.

11. It is important not to leave any area undrawn, textured, or expressed. The sharp tip of the graphite pencil allows us to outline the leaves, apply shading that makes the tree trunks stand out, and draw sinuous lines at the ends of each branch. Everything is detail oriented, except for the sky, where just a few strokes represent several birds in flight. Watch the video of how the texture and the details are created.

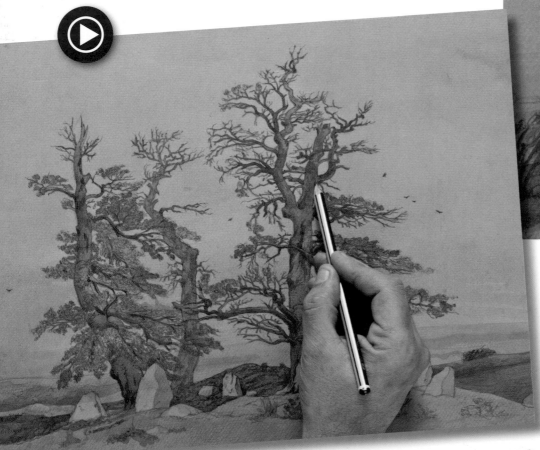

PRACTICE WITH LINES

Before you begin any hatch work, drawing, or texture on paper, we recommend practicing by drawing small lines on a separate piece of paper to test the results.

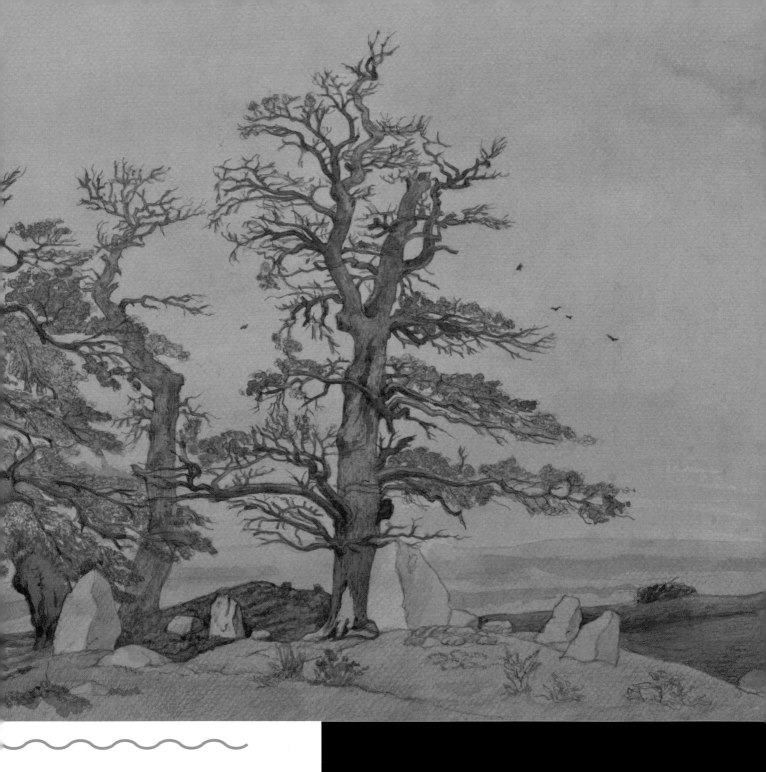

The secret of this drawing is how Friedrich's personality is transmitted through his skillful hand that so easily expresses everything that the artist holds inside. This would explain how Friedrich, specifically in his drawings, was able to confer an aura of beauty, even with the most basic art techniques on the most modest elements in the landscape.

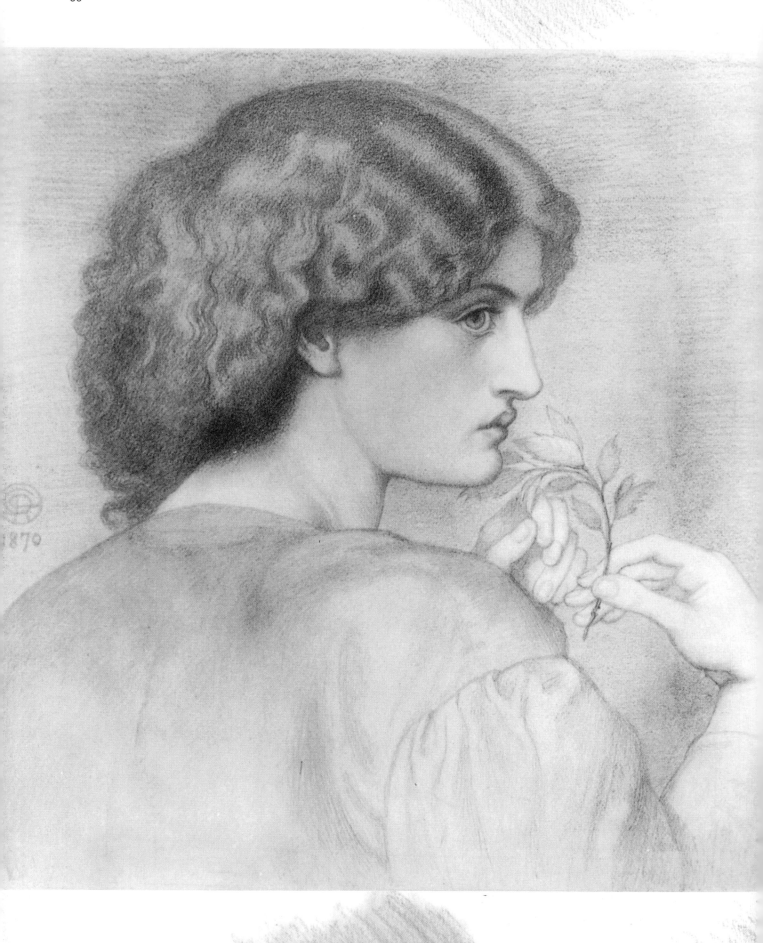

A portrait by **Rossetti**

In the following exercise, we propose drawing a delicate portrait of a woman using graphite. Rossetti was the son of an immigrant Italian scholar and founded the Pre-Raphaelite Brotherhood with John Everett Millais and William Holman Hunt. His work had great influence on the development of the European Symbolist movement. The piece presented here is *The Roseleaf,* a portrait of Jane Morris, the wife of his friend William Morris and the artist's love interest. Rossetti never sold this painting in his lifetime, which indicates the deep meaning that he had for it.

Dante Gabriel Rossetti, *The Roseleaf,* 1870. Graphite pencil on paper, 15³/₈ × 13⁷/₈ inches (39 × 35.2 cm). National Gallery of Canada, Ottawa, Canada.

A Well-Drawn Outline

The paper that we use in this exercise has fine grain; it is smooth and has a slight satin finish. Blocking in the drawing seems simple because it is an easy element to draw without having to use mechanical aides, that is, without tracing drawings or light tables. First, the general structure of the head is laid out with simple geometric shapes, with very light lines using an HB graphite pencil. This can be easily erased, which means that once the drawing is finished, the structural lines will not be visible. The key to Rossetti's drawing was its delicate and stylized nature, as well as the curvature of the graphite lines; this is the dynamic that should be pursued from the beginning. The exercise was done by Gabriel Martín.

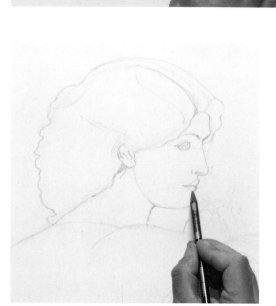

1. Holding the pencil at a very sharp angle, block in the area of the head, face, neck, and torso. A few very light, straight lines and other more rounded lines are sufficient. On the face, a few segments indicate the possible placement of the eyes, nose, and mouth.

2. Begin to define the profile of the figure by working over the initial sketch with a linear, light, yet sharp drawing. It is important to keep the eraser handy to correct as you go. This first phase of the exercise requires great attention, since everything must be well proportioned and defined.

3. Once the face is completed, begin with the most complicated part of the drawing—the torso and the hands. Notice the sketchy nature of the lines, which are not completely defined but will be completed as we proceed.

2

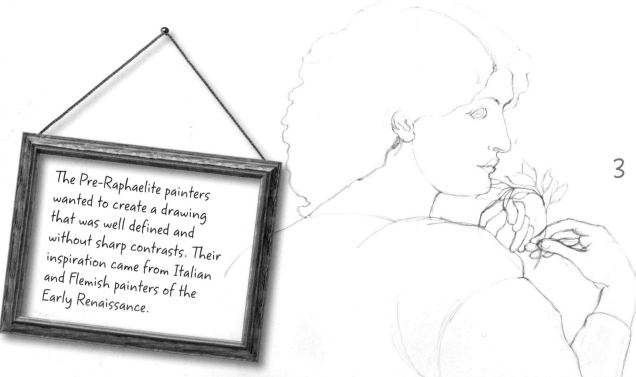

The Pre-Raphaelite painters wanted to create a drawing that was well defined and without sharp contrasts. Their inspiration came from Italian and Flemish painters of the Early Renaissance.

3

4. The shading is done first with a 2B graphite pencil. Hold the upper end of the pencil and apply very light gray tones without applying pressure and leaving barely any pencil marks. In the video, you can see how the shading of the hair is done.

5. The shading should emerge very slowly. The applications should never be dark; instead, the tone should develop as new layers are superimposed over the previous ones. The darker areas of the hair are covered with a light gray, made even throughout.

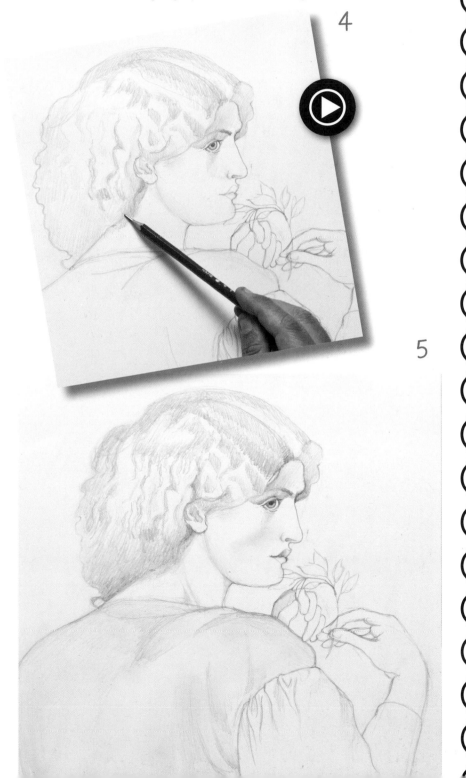

THE SHADING

A. *During the shading process of this exercise, it is important to keep three points in mind. First, shading should be applied with 2B and 4B graphite pencils, angled to reduce pressure.*

B. *Second, the advantage of working with a fine grain paper of a satin finish is that blending with the fingertips is easy, something that is required in the larger areas.*

C. *The blending stump can be used to create darker, more compact gray tones, as well as used to blend the smallest shaded areas in places where the fingertips won't work.*

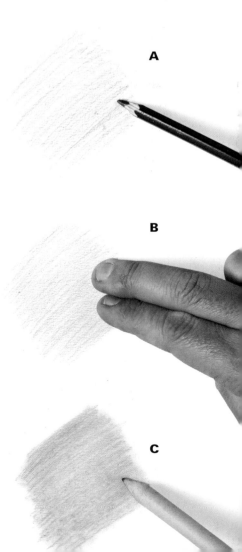

A

B

C

6

Delicate and Solid

The two distinctive features of Rossetti's work are the almost sculpture-like modeling and the meticulous, detailed approach to the features and the hair. In his portraits of women, he rendered them almost like expressions of the divine, as if they were angels with their stylized, beautiful features. Therefore, the character we must convey in the copy should align with these principles. The shading and blending are always very delicate and the contour lines are reinforced with very soft gradations, which give the figure a solid feeling.

7

6. The second phase of the shading is developed with a 4B graphite pencil, a softer pencil that makes a darker line that enhances the contrasts in the hair by darkening the waves. The eye sockets, the eyebrows, and the lips also appear darker.

7. There should be an overall approach to the task. While working on the shading of the hair, which is darker gray where the line is sharper, apply the preliminary values on the dress. Use your fingertips to blend to eliminate any traces of pencil lines.

8. The modeling of the clothing should be very light, barely indicating the folds with light volumes. The small branch that she is holding in her hands is drawn with uniform gray shading. Begin to cover the white background with wide, tight shading, with gentle applications.

8

VERY DELICATE LINES

Once the face is completed with light shading and blended with your fingertips, its time to move on to the hands. First, reinforce the outlines. Then create contrast to play off against the background. To draw a very soft line, lightly rub with the tip of the blending stump. Notice the delicate approach to the hands in the video.

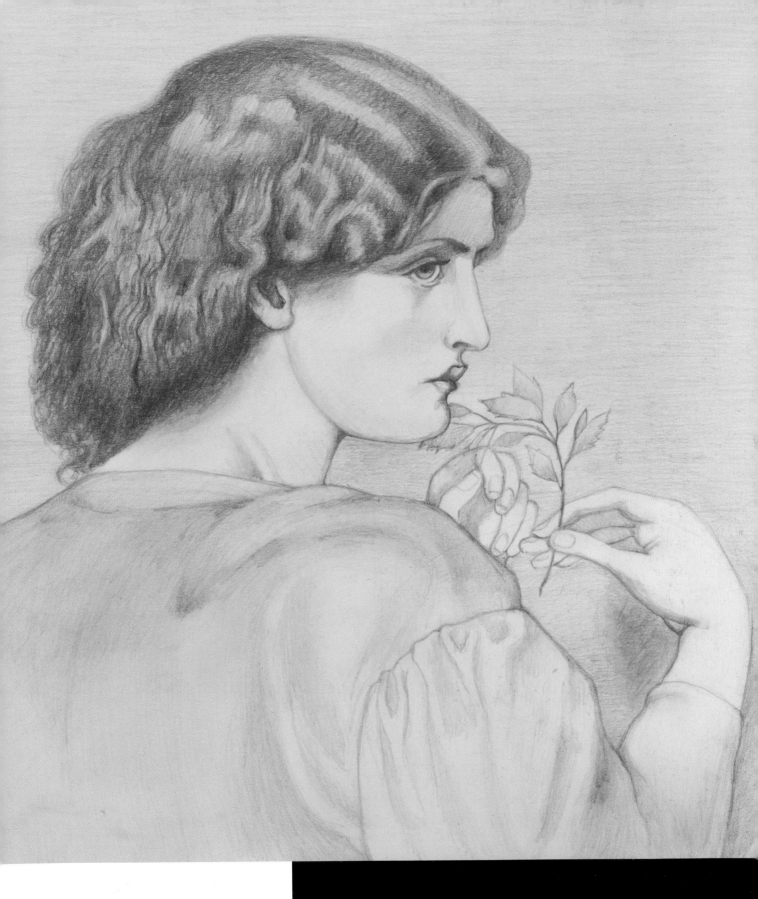

Only the last details remain: darker shading on the upper part of the head, finishing the shading on the dress, and adding new shading around the hand. The final drawing is a head created with "Florentine grace." The modeling of the figure is so delicate that it reflects the artist's attempt at achieving a sort of beauty that transcends spirituality and time.

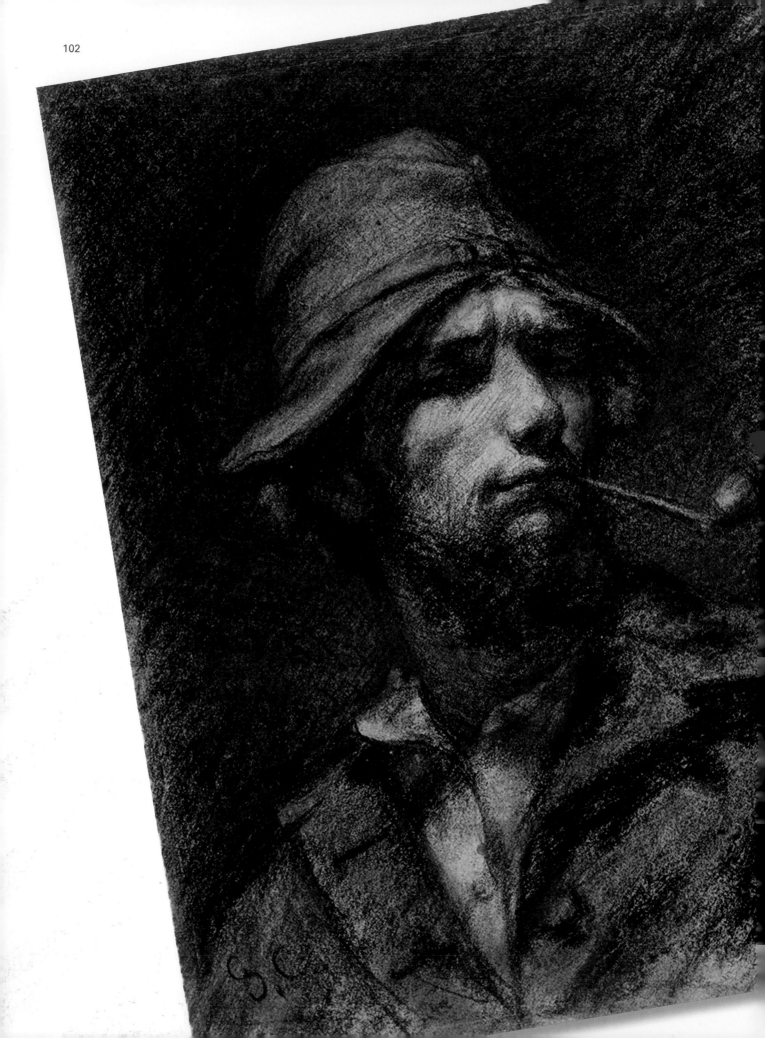

The following self-portrait that we are going to copy is by one of the most important representatives of artistic Realism. The subject matter in this drawing is representative of the portraits that Gustave Courbet made during his youth between 1842 and 1854.

The body of drawings done by this artist is limited, which highlights the importance and exceptional character of this self-portrait. For this work, the artist combined conventional charcoal sticks with black pencil, a type of soft clay pencil that was used with charcoal during the 19th century. Artists like Millet and Courbet, among others, used this technique routinely. We are going to use a compressed charcoal pencil for its ability to tint and its resemblance to black pencil.

Self-Portrait (Man with the Pipe) by Courbet

Gustave Courbet, *Man with the Pipe (Self-portrait)*, circa 1848. Charcoal on paper, 11¾ × 9¼ inches (29.9 × 23.3 cm). Wadsworth Athenaeum, Hartford, Connecticut.

The Pose of Self-Portrait

With this drawing, Courbet pays homage of sorts to old paintings that are reminiscent of Rembrandt's chiaroscuros. But here, light and shadow effects are supported by a strong composition; the face is seen from below, from a low angle, and is accompanied by a dramatic expression, due to its meditative pose and his eyes half closed. It is a representation worthy of the best portraits produced in the 19th century. Let us explore the strategy that he used to block in the main forms. This exercise was done on a medium grain paper by Mireia Cifuentes.

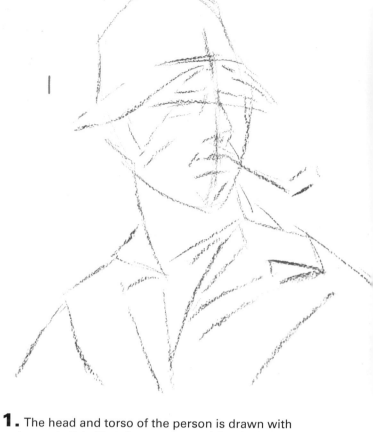

1. The head and torso of the person is drawn with a charcoal stick. First, lay out the oval for the head, followed by the neck and the shoulders. The symmetrical lines for the face are drawn to establish the height of the forehead, the eyes, the base of the nose, and the mouth. This is done in a loose manner.

2. Begin to solidify the forms over the previous drawing. The lines on the face not only outline the facial features, but they also separate areas of light and shadow. This is also true for the clothing.

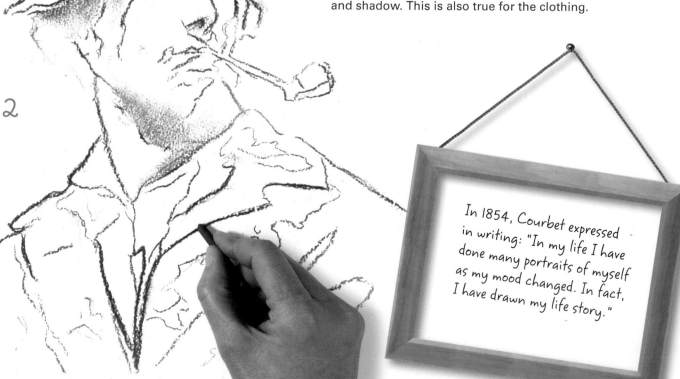

In 1854, Courbet expressed in writing: "In my life I have done many portraits of myself as my mood changed. In fact, I have drawn my life story."

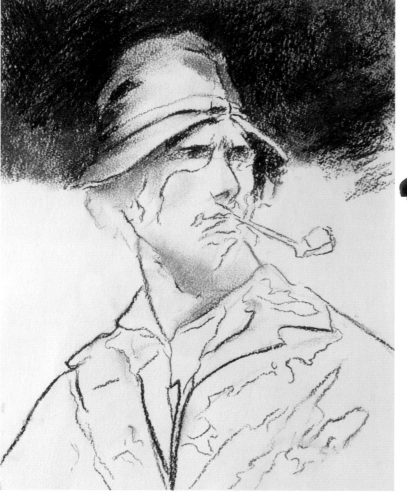

TEXTURED SHADING

Dragging the charcoal stick lengthwise over a medium grain paper produces textured shading that does not completely cover the white background of the paper.

3

3. Once the overall structure has been established with the side of a charcoal stick, begin to darken the background. Blend the shading with the hand gently, without applying much pressure. The darker areas around the hat are made by adding pressure with the stick held on its side.

4. With a smaller piece of stick, about 1 inch (2 cm), apply the main shading of the face, which is blended with your fingertips. The darker shading on the eyes is done with the tip of the stump.

4

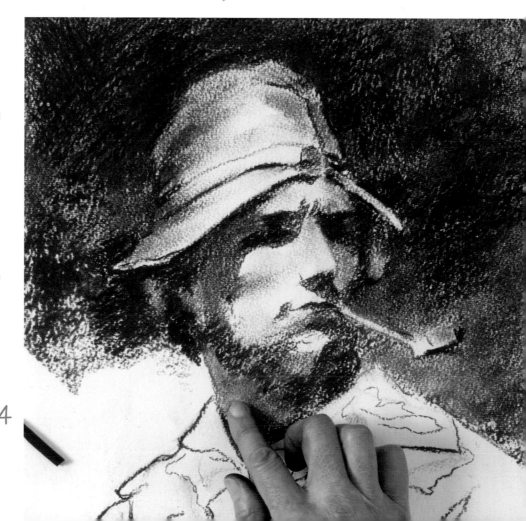

5

Creating the Chiaroscuro Effect

At this stage of his life, Courbet used charcoal and black pencil frequently for his portraits and self-portraits to give the figures a dark and obscure appearance, thus making his own figure dramatic, typical of Romanticism and the Baroque. It is worth remembering that Courbet copied the great Flemish, Dutch, Venetian, and Spanish masters for years. For them, shading and the chiaroscuro effects became especially important. In this stage of the work, we complete the foundation of the shading and the modeling effect, leaving everything ready for the use of compressed charcoal.

6

7

5. Proceed with shading using the side of the charcoal stick, applying more pressure on the background. On the torso, the shading is lighter gray and blended with the fingertips. The goal is to create a scale of three or four different grays. The lighted areas are represented by the white of the paper.

6. The blending stump comes into play to give more depth in the shading and to better control the gradation. Its well-defined tip allows us to work the details. To avoid smearing the charcoal pigment with your hand, it is a good idea to cover the work with a sheet of paper to protect the surface from accidental smudging.

7. As the charcoal lines blend together, the shading lightens and turns a lighter gray. But don't worry, there will be time to darken it and work on the contrast later. The blending stump is the ideal tool to model the face; it makes it possible to define the shading on the pipe, the eyes, the base of the nose, and the mouth. The tip can reach very small areas.

8

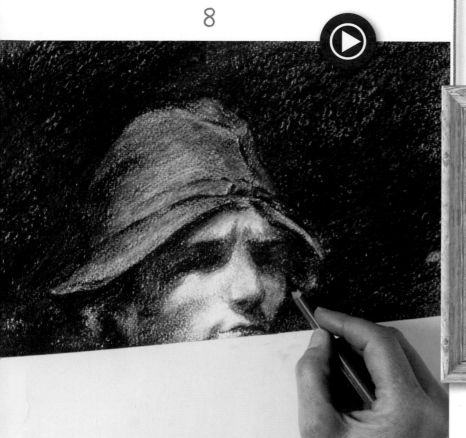

The influence of his work, both in drawing and painting, was extraordinary. He knew how to incorporate the conventions of the formal paintings that preceded him and to show it with new, more expressive formulations, paving the way to the modern era.

8. Before you begin using the compressed charcoal pencil, you need to use a fixative spray over the first shading done with charcoal. After a few minutes the application will dry and work can begin on the hat to darken its overall gray color as well as the shading underneath its bream. Watch the video to see how the compressed charcoal pencil reinforces the dark areas.

9. The face is worked very carefully with the compressed charcoal pencil to reinforce the shape of each element. Hold the pencil at an angle to prevent the lines from becoming too strong. The applications of charcoal are alternated with erasing areas to reveal the white of the paper, thus rendering the highlights of the lighted areas of the skin.

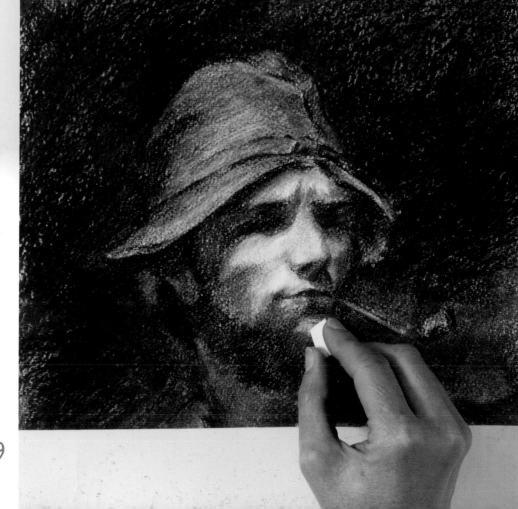

9

10

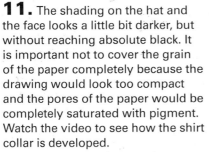

Hatching with Compressed Charcoal

In this final phase, the conventional charcoal is completely left out, working only with a graphite pencil and a compressed charcoal pencil. The compressed charcoal provides contrast and power to the finish of the drawing by achieving very strong blacks, and therefore a wider range of grays than those of charcoal. This way, the chiaroscuro effect will be stronger while the black becomes deeper, the shading more solid, and the modeling more decisive until the final effect of the figure is achieved, looking like it is emerging from a gloomy, dark depth.

10. With a compressed charcoal, go over the dark areas of the background. The point is used to ensure that the diagonal hatch lines are visible.

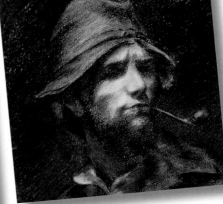

11. The shading on the hat and the face looks a little bit darker, but without reaching absolute black. It is important not to cover the grain of the paper completely because the drawing would look too compact and the pores of the paper would be completely saturated with pigment. Watch the video to see how the shirt collar is developed.

13

11

12

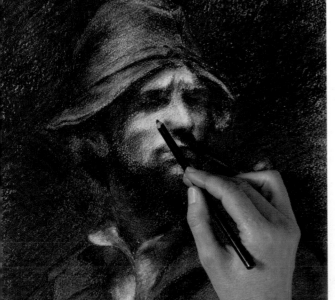

12. The beard and the neck are shaded with the side of the charcoal point. The grays have become more intense but have been developed with great subtlety so the new shading blends with the previous one.

13. The final touches, specifically the effects of the hatch lines on the hat and on the face, are made with a charcoal pencil. The lightly-drawn lines are made with just a slight touch and are drawn diagonally.

The finished portrait illustrates the way Courbet worked, capturing the instant the figure emerges from the dark.

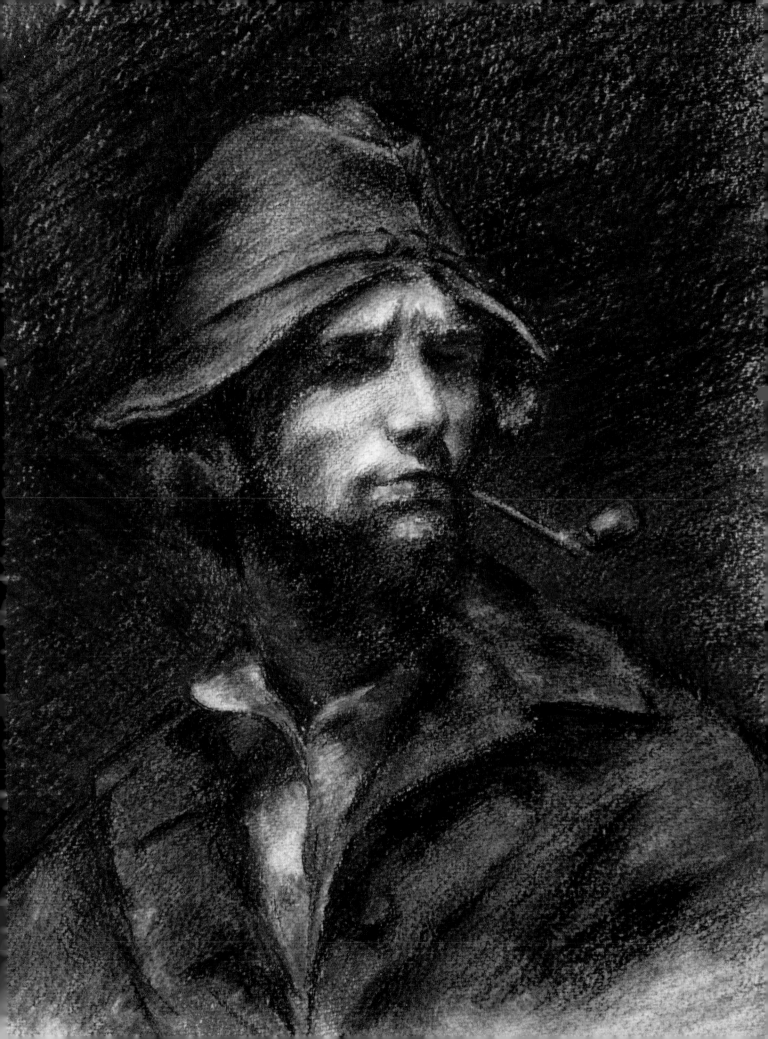

A Street in Abbeville by Ruskin

The following reproduction represents an urban scene by John Ruskin (1819–1900), one of the fathers of 19th-century Medievalism and great theorist of the Pre-Raphaelites and of Great Britain's followers of the Arts and Crafts movement. In addition to being a great drawing master, he was also an art critic, sociologist, and one of the masters of English prose.

During a trip to France and Italy, Ruskin portrayed the romantic beauty of medieval architecture, as it is shown in the representation of a street in the French town of Abbeville with the cathedral in the background. During this trip, he discovered the beauty of the Romanesque and Gothic monuments treasured by Mediterranean countries. The monuments impacted him so much that he devoted himself to the study of ancient architecture and became one of the main defenders of British Gothic Revival as a style of great religious inspiration in 19th-century England. This exercise is faithful to the details and the materials that the artist used, such as graphite pencils, washes, and white gouache on medium tone, reddish ochre Canson paper.

John Ruskin, *Abbeville*, 1868. Graphite pencil, wash, and white gouache on color paper, 19¼ × 13¾ inches (49 × 35 cm). Cecil Higgins Art Gallery and Museum, Bedford, United Kingdom.

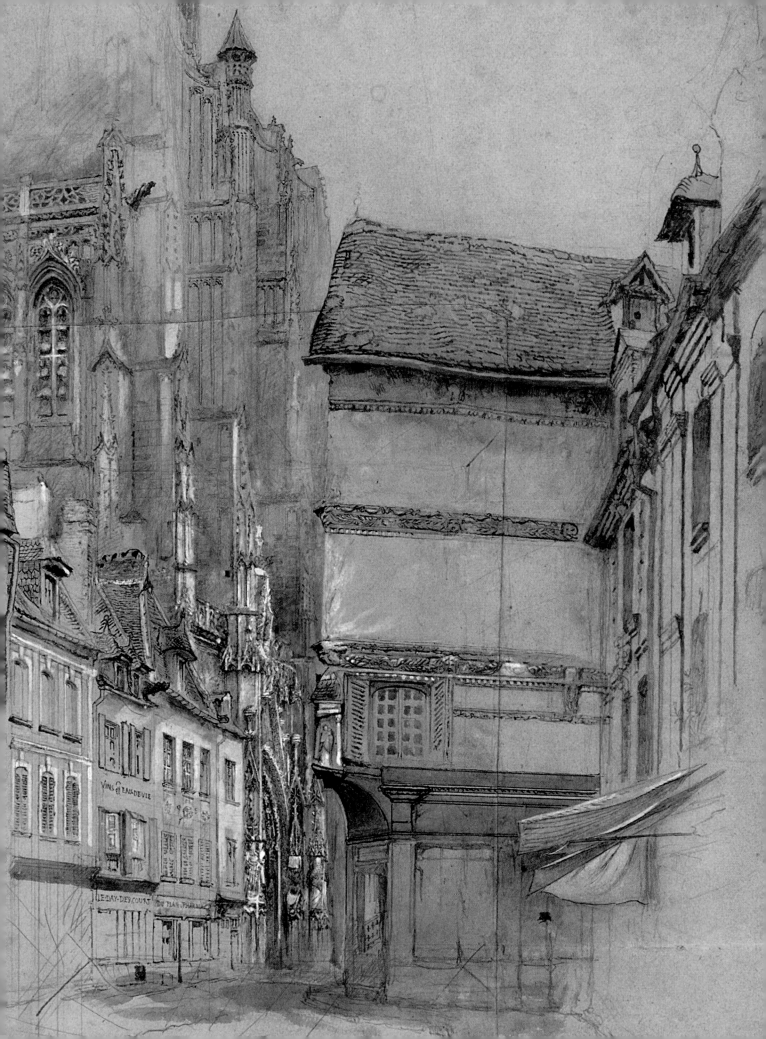

Blocking In the Architectural Forms

There are two basic ways of approaching the drawing. The first one is the traditional free hand blocking in, laying out a clear geometric structure that defines the placement, height, proportion, and perspective of each façade. From this first geometric base made with graphite pencils, the rest of the elements, as well as the details, are drawn. The method is very time consuming and requires constant revising and correcting with an eraser to limit mistakes. For those who lack the patience, given the drawing's complexity and details, there is another option: to make a tracing using a light table or a photocopy enlarged to fit the paper. This exercise was done by Gabriel Martín.

1. With an HB graphite pencil, block in the shapes of the buildings using simple geometric lines. It's a good idea to look at them as geometric boxes attached to each other. The features on the houses that stand out and the upper part of the roofs should have the right inclination to simulate the perspective effect.

CUTTING THE PAPER TO SCALE

There is a very simple method for cutting the paper to the scale of the original drawing that leaves no margin for error. Simply line up the upper corners of the photograph and the sheet of drawing paper. Then place a straight edge over them, across the opposite corner of the model so that it acts as a diagonal line. The extension of the ruler across the drawing paper will allow you to mark the position of the right lower corner of the support's rectangle. Any point that is marked along the ruler to indicate the bottom corner will assure that the cut out sheet will have the exact proportion as the original model.

2

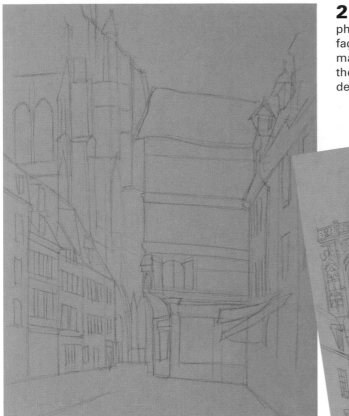

2. Over the first simple structure, lay out the second phase, which will include the main elements of the façade. However, this should still be in a stylized manner without precise details. We must first identify the main elements in order to continue with the details later.

3

3. Now that the blocking in phase is complete, you will start to draw with a very sharp 2B pencil. The objective is to go over the façades of the buildings meticulously to draw lines, with no shading or gradations, and indicate all the details and the most prominent architectural elements.

4. Try to draw the elements on the left side first, then proceed to the right. This way you will avoid smearing the lines by rubbing them with your hand. At this point, the drawing should be accurately defined, with each element in its right place.

4

Empty Spaces and Washes

The starting point is a linear drawing, made with fine lines intended to show all the architectural elements of the façades, with the exception of the tower on the cathedral and the lower part of the street, which look unfinished. Ruskin's predilection for clear, well-defined outlines is in contrast with the tradition of leaving parts of the drawing unfinished, resulting in particularly expressive representations, which is why it is important to leave some spaces blank. Many 19th-century artists completed the shading with a graphite pencil applied very lightly over a watercolor wash base. This created a nearly imperceptible base that blended easily with the thin hatch lines of heavy gray made with the pencil.

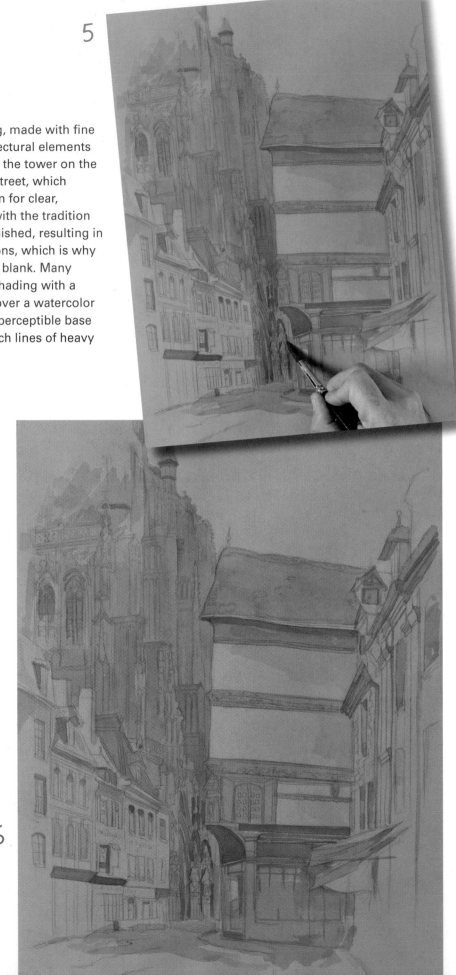

5

5. With a very diluted burnt sienna watercolor wash, paint the façade of the cathedral to highlight the architectural features. At first, the paper will buckle, but after it dries it will go back to its original state.

6. The shaded background of the cathedral's Gothic façade emphasizes the light that shines on the houses in the foreground due to the contrast. The darker areas are made darker with a second wash.

6

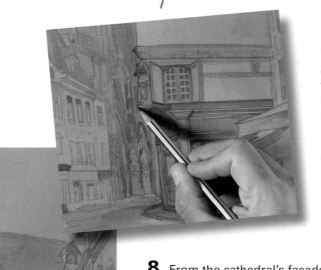

8

7. Once the washes are complete, the support is left to dry at least for 30 minutes so the paper can regain its smoothness. On the dry base, reinforce each detail with light shading using the 2B graphite pencil.

8. From the cathedral's façade we see the pilasters, blind arches, and additional reliefs emerge slowly and characterize the Flemish Gothic style. With darker lines and more contrast shading, begin to build up the lower area of the building's façade on the right.

9. Now drawn are the tiles of the roof, the windows, and the borderline between the foreground and the background areas, outlined with double lines.

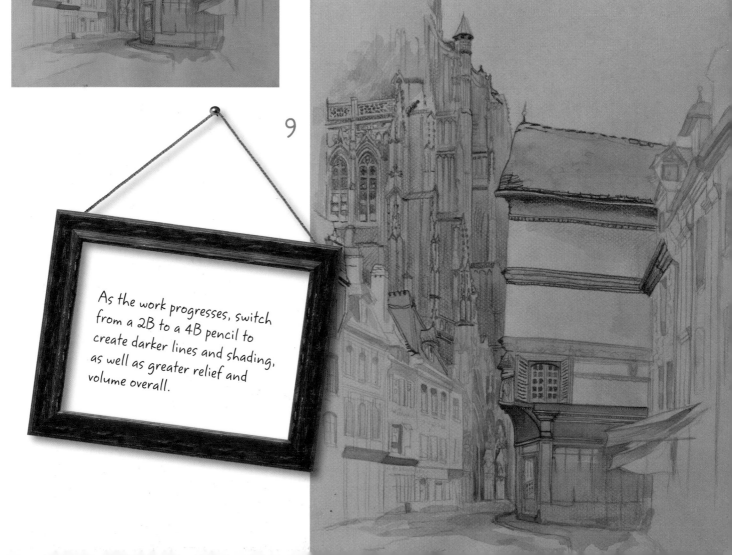

9

As the work progresses, switch from a 2B to a 4B pencil to create darker lines and shading, as well as greater relief and volume overall.

10

A Profusion of Details and Highlights

In the last phase of the work, you must indulge in the luxury of details that Ruskin's drawing offers. Go back to the graphite pencil and apply new highlights with white gouache.

The artist drew the buildings as if they were large architectural sculptures full of lines, shading, gradations, highlights, and splashes of light. His drawings were like jewels that invited the viewer to observe all the details, plays of light, shadow, textures, and descriptive aspects. It was a way to reinforce his ability for observation, for compiling and registering information, and for learning about the world.

10. Details are fundamental to understanding the work of John Ruskin; therefore, it is important not to disregard the roofs and façades of the buildings in the foreground, even though the first two on the left should be left unfinished. Before starting with the gouache, spray the drawing with fixative. The video shows the meticulous work on the façades.

11. Using a very thin brush, add highlights on the façades of the houses and between the architectural and decorative features of the cathedral. If a wash color turns light after it dries, you can make it darker by adding another layer over the previous one until you get the desired shade.

12

11

12. After allowing the gouache to dry completely, add the final touches with a very sharp pencil. Correct the areas of color if needed and darken the whites if they are too bright. Watch the video to see how this process is carried out.

After balancing the whites and the grays, the drawing is finished. The meticulous work of creating the various tones of gray on color paper combined with the white highlights give the drawing a strong three-dimensional effect, following the dynamic style of John Ruskin's masterly work.

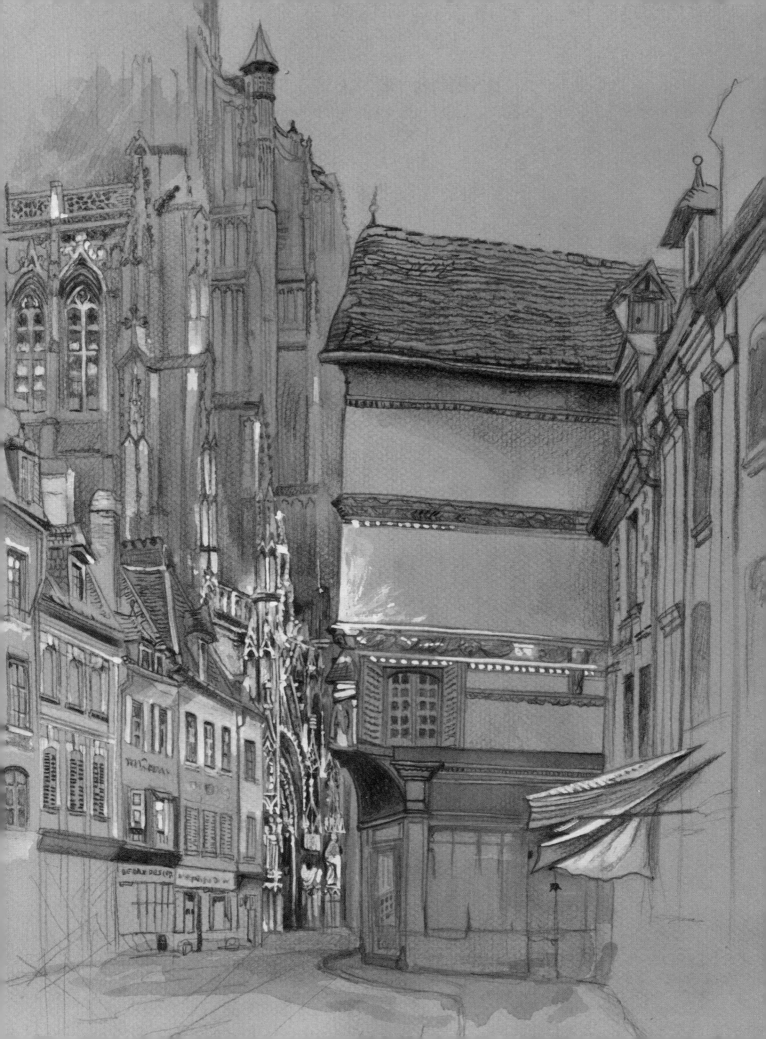

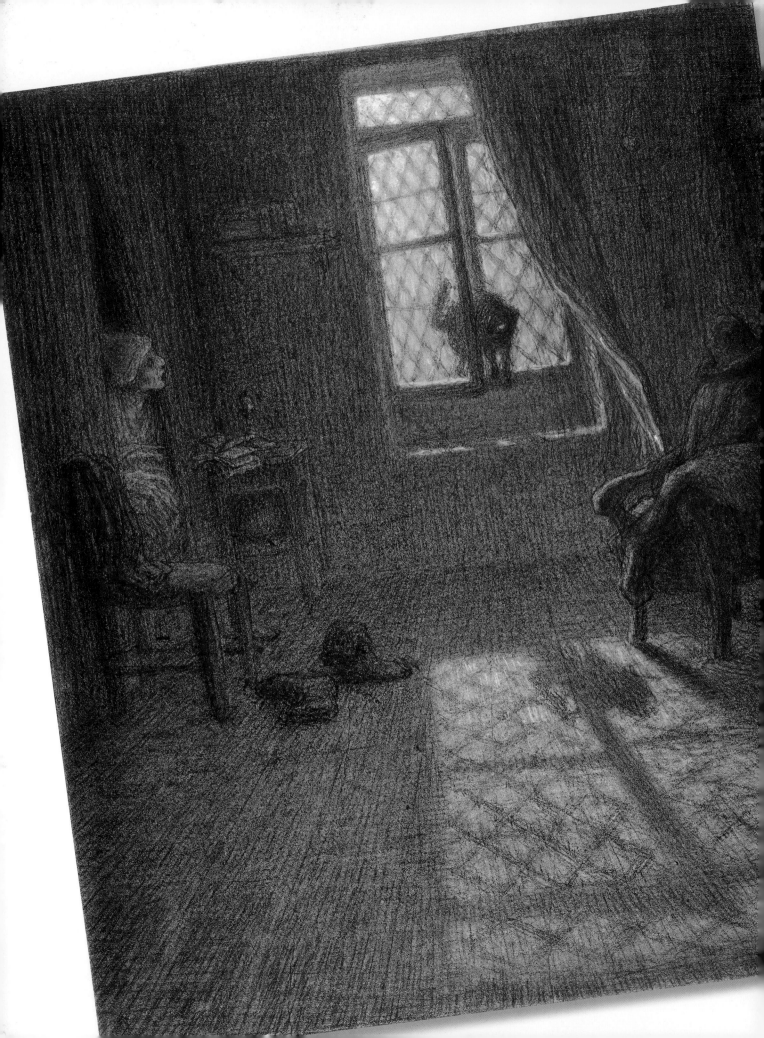

The Cat at the Window by Millet

Jean-François Millet, *The Cat at the Window*, 1857–1858. Charcoal, black and white chalk with touches of pastel, 19⁵/₈ × 15¹/₂ inches (49.8 × 39.4 cm). J. Paul Getty Museum, Los Angeles, USA.

Jean-François Millet (1814–1875) is known as one of the great Realist painters of the 19th-century, but he was also a productive draftsman who made numerous studies and sketches that have served as an important source of inspiration for artists that came after him. His best-known scenes are portraits of rural life, of the laborious yet pleasant world of country people. However, for this exercise, we have chosen an interesting interior with a clear literary theme. In this work, the light of the moon comes into the room through a window. There we see a cat with bright eyes observing an emaciated man whose head peeks through the curtains that cover his bed; nearby, his clothing rests on a chair and his boots are on the floor. This is an illustration from a fable by La Fontaine, *The Cat Metamorphosed Into a Woman*, which makes the point that appearances cannot hide a person's true character. The artist used charcoal, chalk, and an occasional touch of pastel.

The Choice of Paper and Shading

Millet drew this nighttime interior on a medium tone paper. However, just as the copyist is free to choose whether or not to use different drawing materials than those used for the original model, he or she can also select a paper color that is different to emphasize particular graphic effects. In this case, we will work with a laid paper that is somewhat lighter than that used by the artist so that the hatch lines will be more visible and provide contrast with the background. In this first phase of the drawing, we will use charcoal only to block in the perspective lines of the interior space and to cover it with a very light shading. This exercise was done by Teresa Segui.

1. The model is extremely simple and can be indicated with a freehand sketch without the need for tracing or other transferring techniques. Start constructing the sketch with the central window, projecting the straight lines from the edge of the curtain and the lines of the floor.

2. The lines should be accurate and simple, just rendering the elements that appear in the scene. It is best to work with a thin stick about 3½ inches (8 cm) long and be careful not to make the lines too dark.

1

2

CHOOSING THE PAPER

Before you begin, make several tests on fine grain paper of different tones. Try to copy the lines in the drawing so you can decide which will be the best support for the copy.

3

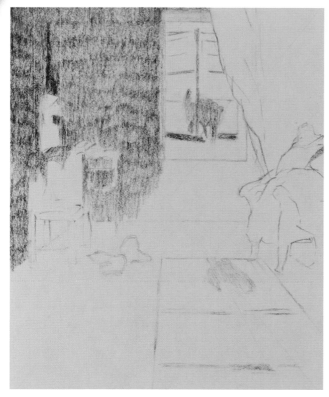

4

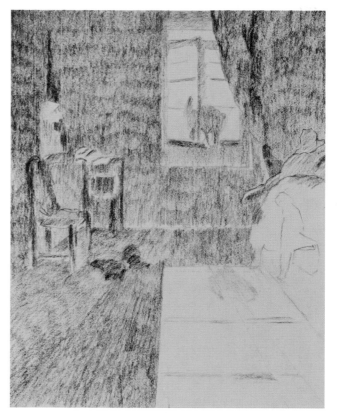

5

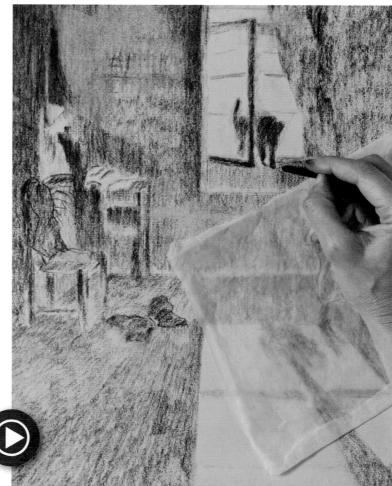

3. Use the same charcoal stick to shade the interior with a series of tight lines that almost completely cover the background. Begin shading at the upper left. Use a minimal amount of pressure and just lightly touch the paper.

4. In a few minutes, the gray will cover all the dark areas of the interior except the window and the reflection on the floor, which is the color of the paper. On the floor, the line work continues as it follows the perspective of the room, creating diagonal lines that converge at an imaginary point in the background.

5. Break up the uniformity of the gray by darkening the elements that are in the room: the furniture, the objects, and above all, the cat that is barging in through the window. You should rest your hand on a piece of paper to protect the layer of pigment on the support and to keep from smearing it. The video shows how the lines made with the charcoal stick are applied.

6. Use a black chalk pencil to detail the shapes of the objects that are next to the bed, as well as define the phantasmagoric face of the figure. The lines should be fine and not too dark. Continue using a piece of paper to protect the surface of the drawing from being smeared by your hand.

7. Apply light blended shading to emphasize the objects and give them an atmospheric look that won't clash with the feel of the interior. It is done with hesitant lines that project indistinct shapes on the floor.

Idealizing the Forms with Chalk

You have now created the initial overall shading, which is still vague and very atmospheric but will serve as a base for all the subsequent shading work. In this second phase, you will outline the figure, the cat, and the rest of the elements that decorate this interior. You will use a black chalk pencil for the outlines, with the silhouettes all done with fine lines to give the objects more body. They are clearly idealizations resulting from stylized indications of the forms. Combining the chalk with the charcoal is a progressive process of darkening, achieved by overlaying lines.

8. The boots stand out from the background, thanks to their outline and shading. Now do the same to the clothing and the hat that are on the chair at the right. A chalk pencil, which makes darker lines than charcoal, will allow you to easily create contrast on the shapes.

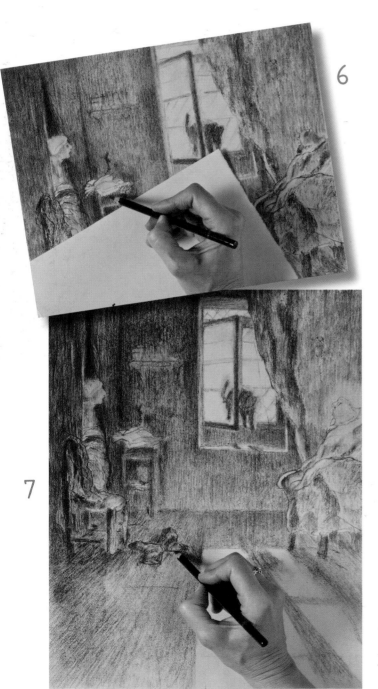

6

7

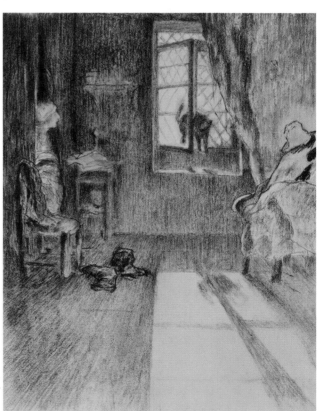

8

The goal is to progressively darken the scene until it arrives at the same level of darkness as the original model.

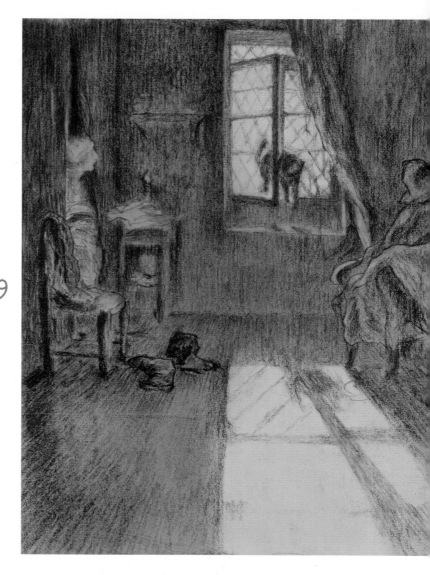

9

9. A new set of perpendicular lines lightly cover the previously drawn lines on the wall in the background and diagonal lines on the surface of the floor. The more contrast you create, the greater the effect of the light coming in through the window.

10. Use the charcoal stick to work on the reflected light that is projected on the floor that advances toward the foreground. Indicate the frames of the diamond windowpanes with very light lines then later go over them with some black chalk lines.

10

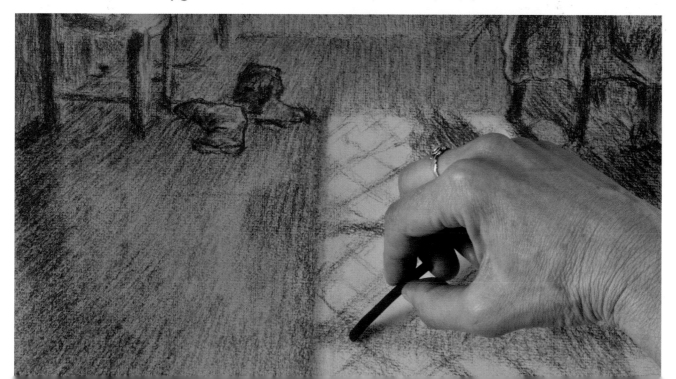

Enchantment and Mystery

Millet floods the interior of the room with fine hatch lines drawn with black chalk, giving the scene a very atmospheric aspect. The tones hide the outlines of the objects and make them hard to see, as if everything is wrapped in a dark shadow of enchantment and mystery. To create this nocturnal feeling, the artist used a subtle overlay of black chalk lines that contrast with areas of light. This gives the scene a lack of solidity, a very ephemeral treatment and a suggestive atmosphere. It all culminates with the addition of white chalk and even a few touches of white pastel so that the reflections of light will be even brighter.

REFLECTIONS OF LIGHT
White pastel can be combined with white chalk, especially when the reflection has to be more intense and bright.

11. With a stick of white chalk, apply the highlights on the curtains draped on the bed. When added lightly over a heavily shaded area, the gray color of the charcoal is transformed into a silvery gray tone. Whiten the person's cap using the same color.

12. To represent the light from the window, alternate the stick of chalk with a stick of white pastel. The pastel will be more opaque and the reflections more intense because it has more pigment than the chalk. In the areas that require more meticulous work, you can use either medium. See the process in the video and watch how the white reflections are applied.

13. Use the black chalk pencil to add the final touches to the light projected through the window before adding any white highlights.

To complete the scene, work on the light projected through the window in the foreground to create beautiful contrasting light and shadows. When it comes to Millet's Realist esthetic, notice how the drawing purposely avoids becoming too detailed and yet how true to life it is. You can see his interest in light and its effects, reminiscent of the Impressionists.

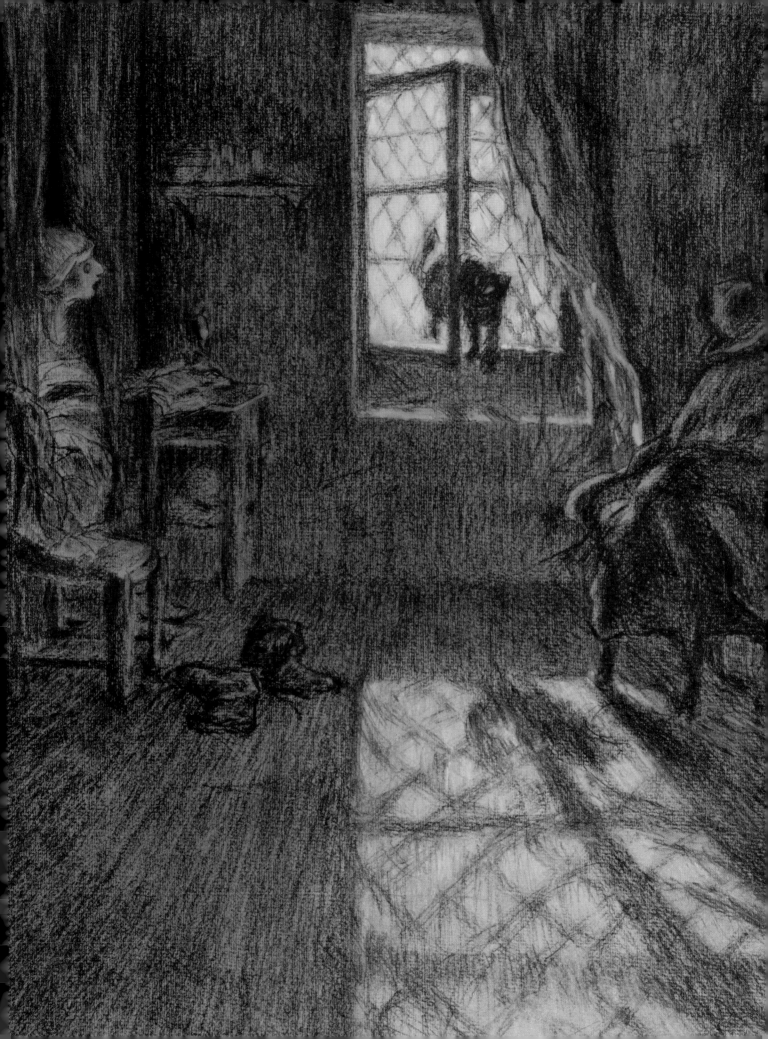

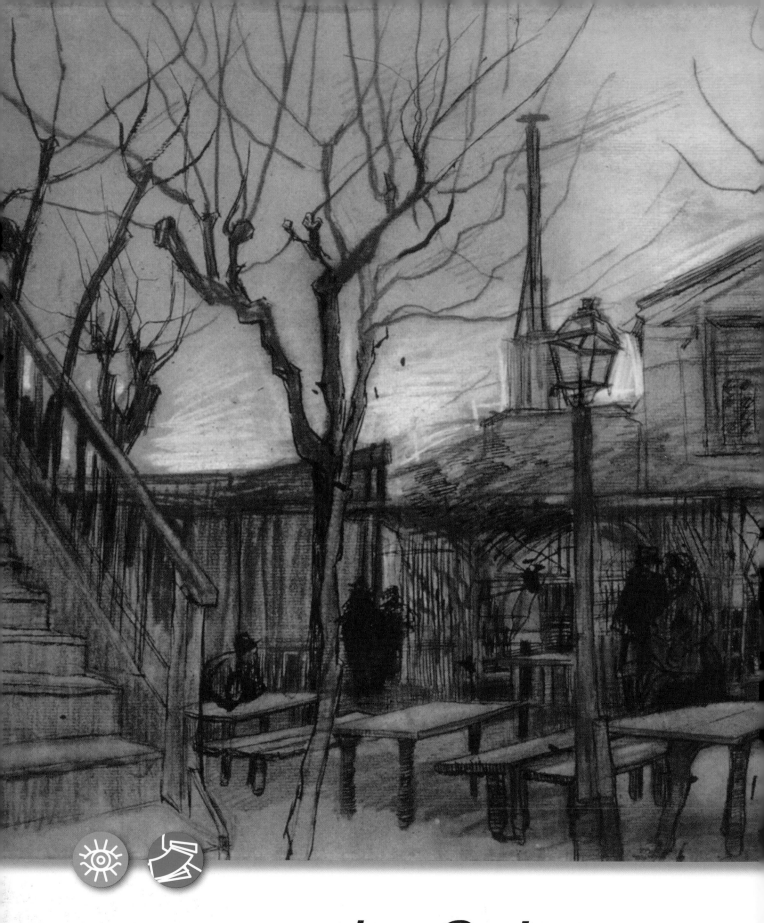

La Guinguette

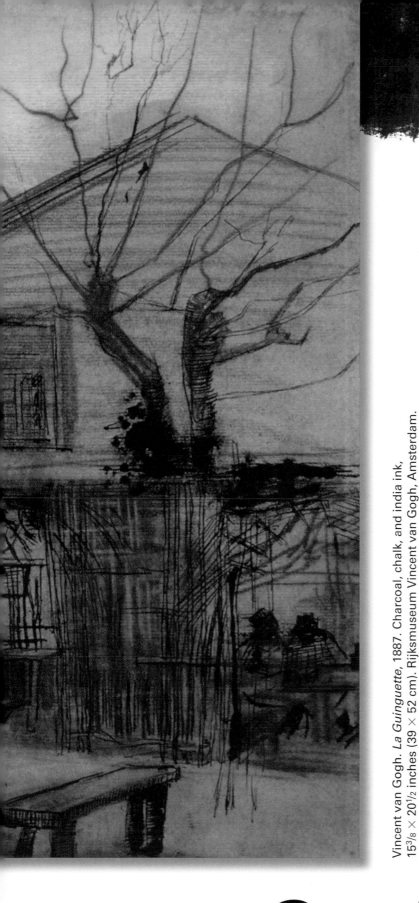

Vincent van Gogh. *La Guinguette*, 1887. Charcoal, chalk, and india ink, 15³⁄₈ × 20¹⁄₂ inches (39 × 52 cm). Rijksmuseum Vincent van Gogh, Amsterdam.

This drawing represents a *Guinguette*, a kind of cabaret typical of the Paris suburbs that consisted of a restaurant with a terrace and an outdoor dance floor. It was drawn during the time van Gogh was in Paris, where he made a series of drawings with a lot of shadows that caused him to reconsider the effects of light and the use of color in his creations. In this drawing, we can appreciate the realism of the Dutch school: the taste for chiaroscuro, for the basic contrasts of light and shadow, and the thick dense applications of tone that nearly cover the thin and delicate lines made with pen and ink. Nonetheless, the sketches of people and the highlights he used make us think that these were early experiments with Impressionism.

by van Gogh

Shading as a Cohesive Element

The following drawing should be somewhat vague and communicate the apparent indifference of the Impressionist style. This means converting, in an almost mechanical way, everything you see into a sketch-like painting with lines and areas of charcoal. The key to the initial sketch is the shading, which will be a unifying element that covers the entire space and supports everything in the picture. This drawing, by Teresa Segui, was done on paper tinted with a wash to create a color similar to that of the original.

1

1. The drawing is made with a thin charcoal stick. The strokes are very light and linear, with barely any pressure applied in making the charcoal marks.

2. Wipe the drawing with a charcoal rag so that the lines are almost invisible, just dark enough to act as a guide for the first steps of this exercise. Tint the paper with a watercolor wash of burnt umber mixed with a little Payne's gray.

2

3

3. After the wash is completely dry, apply some lines with the charcoal stick and follow the marks of the initial drawing. These gray strokes will help emphasize the first shapes, which are the most evident.

4. The buildings in the background of the scene can be built up with shading applied with a charcoal stick. Press lightly and smooth its marks with a blending stump. The furniture in the foreground should be created with drawn lines.

5. You can work with more precision when using a blending stump, especially in small tight spaces and where you need to outline the shaded areas.

4

5

Unlike your fingers, a blending stump will leave a visible mark on the paper, so you must be very aware of the direction when you blend shading.

6. The tone of the paper can be darkened even though the drawing has already been started, due to the fact that the charcoal doesn't act like pigment and is not very water-soluble. You must use a soft brush and only go over the lines a single time.

6

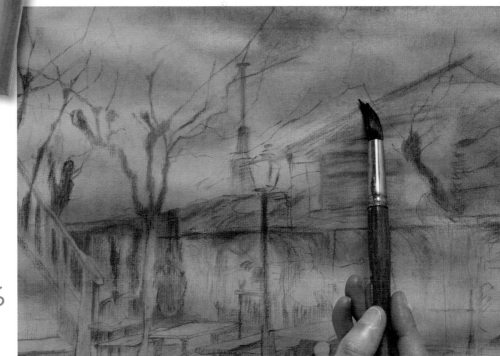

Ink Over Charcoal

The watercolor wash not only changes the tone of the paper, it also helps fix the charcoal to the support. It also makes the next phase of the drawing easier, consisting of adding lines and details with india ink using tools like reed pens and metal nib pens. This will create a perfect balance between adding body with the charcoal shading and defining the shapes with fine ink lines that make the drawing more expressive.

7. Dip a reed pen, with its natural handle and carved nib, into a container of ink, then use it to add a few lines to the main branches of the tree. Protect the drawing with a piece of paper to avoid smearing it. The video shows the process and the first additions of ink.

8. The different line widths and their intensity will depend on how much ink the pen can hold and how fast it runs out when you use it. If you wish to create a greater variety of tones in the background, just add more shading with a compressed charcoal pencil.

9. The thinnest branches can be drawn with a nib pen. Use similar lines to outline the trunk and the handrail of the staircase. Practice these lines on a separate sheet of paper.

7

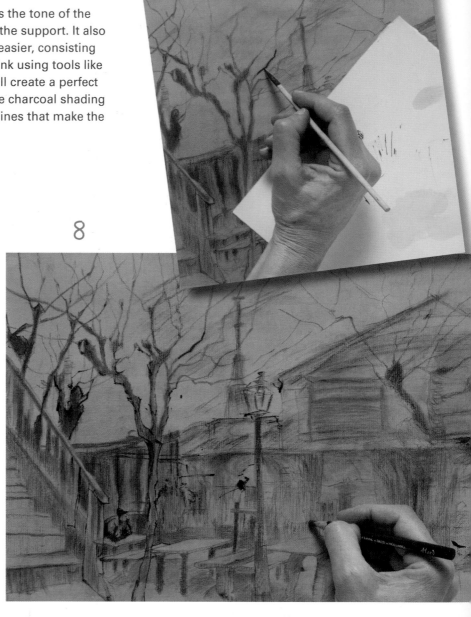

8

9

BETTER OUTLINES

van Gogh often used pen and ink details to finish his drawings. The reed and nib pen lines helped define the outlines and textures of the drawings that he made using charcoal and chalk.

10

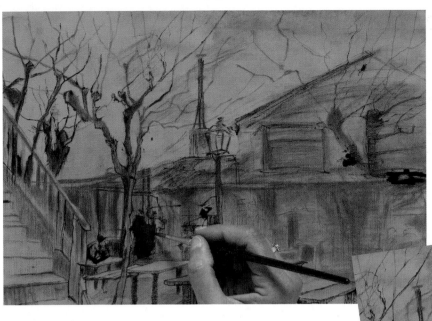

10. Use a fine round brush to work on the masses of the darkest shadows, applying splotches and small marks in the background. In this phase, it will help to use both a brush and a nib pen.

11

11. Sketch in the figures with the tip of the brush while defining some of the details in the architecture of the wood house. The darkest areas should only be referenced and have a loose feeling.

12. When this phase of the work is complete, the drawing should have a perfect balance between the masses of the shading done with the charcoal and the definition from the addition of the ink lines and marks. Notice the compositional importance of the dense blacks that appear in the center of the drawing.

12

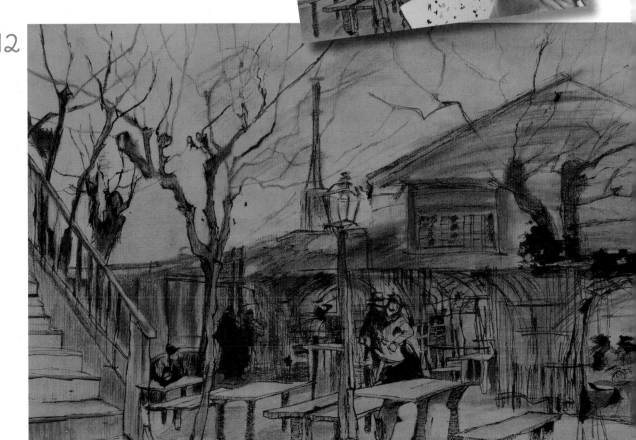

Integrating the Lines and the Final Impact of the Light

In this work, van Gogh begins to suggest a typically Impressionist view: the sky illuminates the benches while the figures are sketched with loose lines that render a pleasant moment of daily life. To keep the ink lines from contrasting too much, darken the compressed charcoal gradations and model them with the blending stump, making sure the shadow does not accidentally flow into the illuminated areas. The highlights are left for last to create the greatest possible contrast between the light of the sky and the atmosphere of the terrace.

13. Add some more charcoal to the background of the drawing to darken the tone of the façades of the houses and the people. Spread the charcoal powder with the blending stump, taking care not to invade the most illuminated parts of the tables and the lamppost.

13

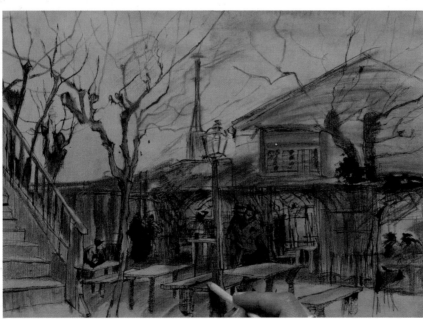

OPENING UP SMALL LIGHT AREAS

Use a refillable eraser to open or recover some white spaces in the lower part of the drawing. This type of eraser will allow you to work accurately in very small areas.

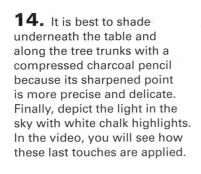

14

14. It is best to shade underneath the table and along the tree trunks with a compressed charcoal pencil because its sharpened point is more precise and delicate. Finally, depict the light in the sky with white chalk highlights. In the video, you will see how these last touches are applied.

The highlights help outline the tops of the wood houses, creating the lively contrast between the intense light of the sky and the darkness in the area of the terrace. Emphasize the hatch lines on the stairway steps and the exquisite gradations that can be seen on the benches and tables in the center of the scene.

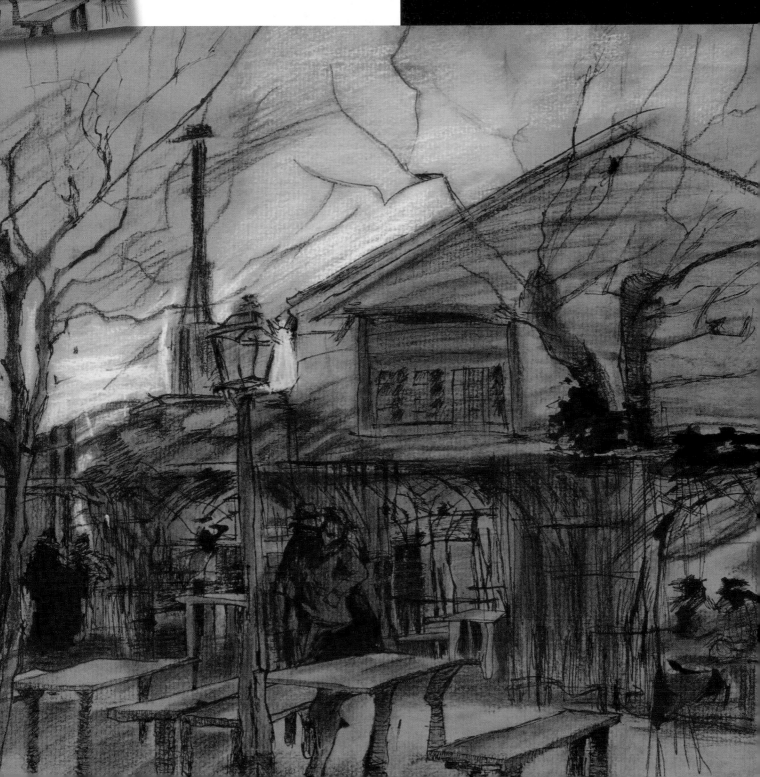

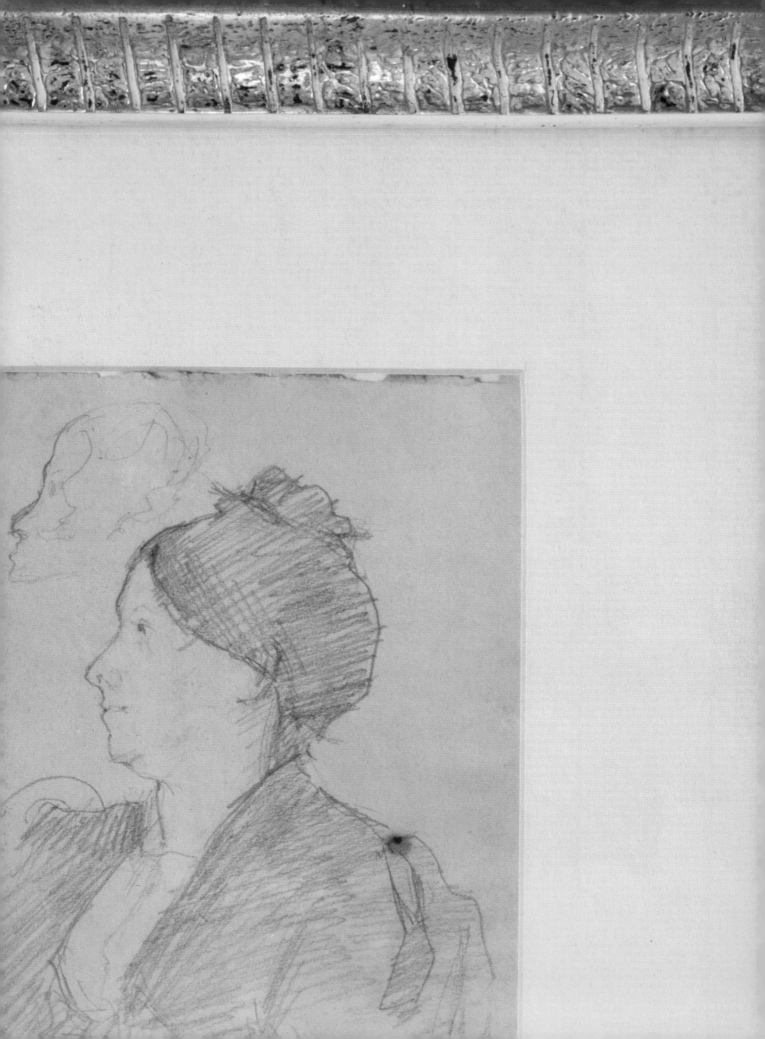

A Good Work of Art Finished

Before this book ends, it may be worth making note of things in this last section so that you can create the desired final effect.

There are some ideas that will help you achieve an accurate interpretation of the real model, a few tricks for integrating washes, and different forms of adding light to create a more volumetric representation of the model. The copy of a drawing done by a great master culminates with being preserved with glue or spray fixative and the choice of an appropriate mat and frame, preferably matching the style of the work that was copied. The frame and the glass not only protect the drawing from scuffing and loss of pigment, they also add emphasis and strengthen the presentation, converting it into an elegant decorative object.

The frames of drawings made by the old masters can serve as inspiration. Take a look at this one by Mary Cassatt.

Improving the Work with Washes

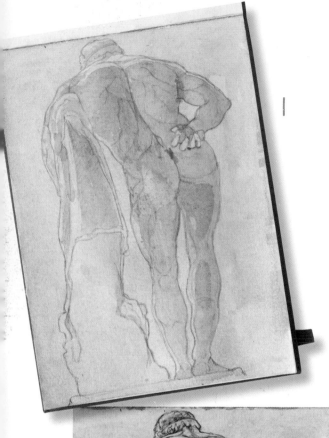

A good copyist should learn to manipulate the paper according to his or her needs. They will not always find the texture and tone they are looking for, so they must be ready to use washes to create the most appropriate color for the background of the drawing, or for giving it a more antique look. The background colors that work best are the neutral tones, blues, browns, and grays. Another way to tint the paper and make it look old is to dip it in a solution of coffee and water, or even an infusion of tea. After it dries, the paper will have a more subdued color and even look a bit muddy, which will give the drawing a more convincing look. The washes are usually applied to the surface that you will work on; however, Jean-Étienne Leotard experimented with a technique that he frequently used in his portraits that was adopted by other artists of his time. To increase the illusion and enchantment of his drawings, he applied a wash on the reverse side of the drawing paper. When the wash was absorbed, a faint color would appear on the front side of it. This can be clearly seen in his drawing *The Young Roman Girl*, where the tones of the hair and the red bands on her dress are the result of the stains on the back of the paper. To apply this technique, all you have to do is cover the back of the paper with bright colors that can be faintly seen through the support.

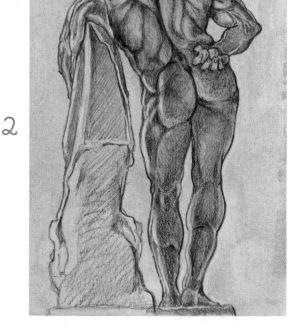

2

1. The wash will also strengthen the effect of the shading on the figure drawn with a graphite pencil. Here is a copy of an old drawing where the flesh tones are indicated with a watercolor wash.

2. As you apply the shading with the graphite pencil, the washes and the grays blend to create a more compact and homogeneous unity. The drawing is then completed by applying a few white highlights on the edges of the figure.

Glazing, or overlaying washes, is the best way of controlling the intensity and diversity of the tones.

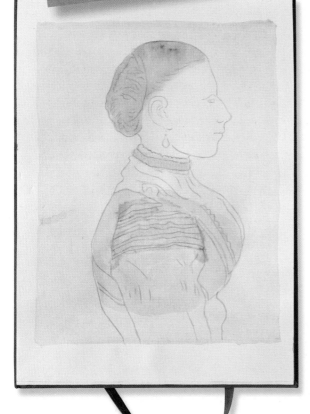

Jean-Étienne Leotard. The Young Roman Girl, *circa 1737 (Private Collection, Jan and Marie-Anne Krugier-Poniatowski).*

1. Apply some wet washes on the back of the support, making sure that they will be seen through the paper. The paper must be quite thin for this to work, between 70 and 90 lb. (100 and 150 gem).

2

3

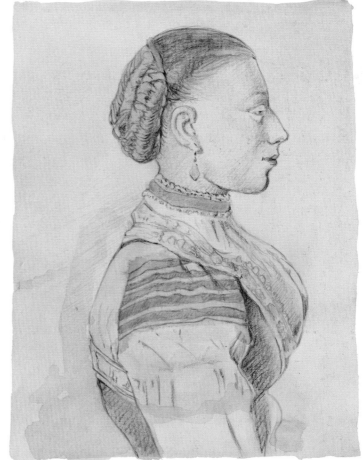

2. In the sketch for the drawing, you can see the streaks of color from the back of the paper in the hair, the collar around the neck, and on the dress. The rest of the drawing is covered with a very light wash of ochre.

3. When you draw over them with chalk lines, the effect of the washes on the back of the paper blends naturally and the changes in tone are delicate and subtle.

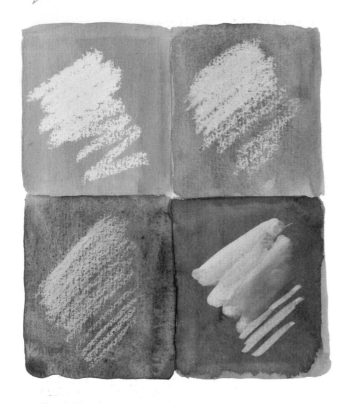

The intensity of the highlights depends on the intensity and opacity of the lines made with the pastel, the stick of chalk, the Cone crayon, or the gouache, and the value or intensity of the color of the background of the paper.

Highlights
on Toned
Backgrounds

Highlights, which were a very common technique used by the great drawing masters, are usually applied in the final phase of the artwork. They assume the presence of a direct and intense source of light on the model, in the form of very saturated reflections and light areas. They emphasize the volume of the represented forms by strongly contrasting with the shaded areas. The great masters of the past regarded this effect very highly for its ability to emphasize the relief on the volumes and for adding bright points that help point out the texture and smoothness of a specific surface. The highlights are usually added using white chalk or pastel and even gouache or opaque white ink, and always when the drawing is finished or in its final state. When you are working with highlights, it is important to consider the tone of the paper, since the greater or lesser effect of the highlight depends on its

The final results are surprising. The highlights themselves become a very effective technique for outlining and emphasizing the shapes of the trees.

The goal of highlighting is to represent pure light, as well as the strong contrast between the middle tones and dark tones of the shadows of the vegetation and the light of the dawn sky, which is completed with white gouache.

Use the lightest colors of chalk for making the highlights, while the black and gray chalk can be used for darkening the shadows.

The white chalk highlights are very expressive when used for the "two color" technique. Here they are blended with charcoal to make gradations and smooth transitions of tone.

contrast with the tone it is applied over.

The middle tones allow you to work with the effects of shading and light in a more balanced manner that is clearly differentiated from the background color. Another key factor is controlling the intensity, especially when using chalk and pastels. The whiteness of the highlight depends on the pressure applied to the support with the chalk. A white line that is too intense can be very difficult to erase, especially if it is mixed with the underlying chalk or charcoal pigment. Therefore, it is best to be cautious and avoid exaggerating the highlights; just add them accurately, carefully, little by little, in several phases until you find the most appropriate tone.

When it dries, the gouache forms a solid layer that is abrasive enough for the pencil lines to adhere well. You can use very delicate lines and even gradated shadows.

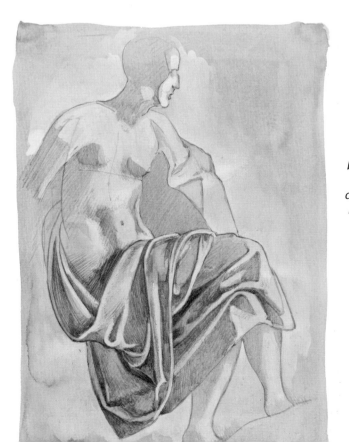

Here the highlights come before the drawing. The figure is constructed with washes of white gouache on a light brown color background. After the gouache has dried, the drawing is completed with a graphite pencil.

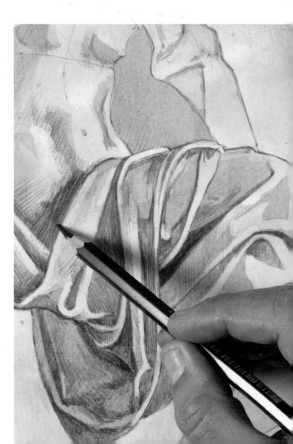

Personality in the Copy

A

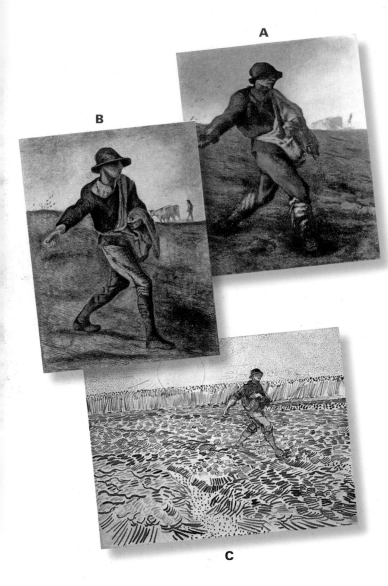

B

C

The great masters have always been a reference for students and lovers of drawing and painting, copyists, and imitators who take pains to emulate their styles. However, this reverence does not have to be total. It is clear that the admiration and the representation are the most appropriate way to make a copy, but you should adapt the exercise to your way of working, allowing your own personality to be expressed in the work, changing the tone of the paper and even the materials that you are working with. These modifications have already been made, however slightly, in some of the exercises included in this book.

If you make the copy freehand, in a spontaneous way, without worrying about making an accurate initial sketch, it becomes a good interpretive exercise that is clearly different from the original model. This work was done by Teresa Seguí.

A. Many artists look for inspiration by copying works by the great masters of the past. Notice this painting of a man sowing seed by Jean François Millet.

B. Based on the work by Millet, van Gogh created different versions of the same model without trying to make an exact copy, but rather something a bit freer.

C. The study of this figure inspired numerous drawings and preparatory sketches for some of the most well-known paintings of van Gogh.

Women Ironing, *by Edgar Degas, is a firm starting point for making a study in graphite pencil that will allow you to analyze the distribution and application of the shading, and other compositional aspects. Copy made by Teresa Seguí.*

Copying does not always mean making the interpretation to an exact likeness, trying to be accurate in every way possible, so that the viewer will be faced with differentiating the copy from the original. There is another way to work: make looser drawings. They may be based on old master drawings, but they have no intention of more than being inspired by the composition or shading, rendering a small homage without having to be an exact replica. Therefore, the copy can become a way of practicing a style, of elaborating in a sketched form the works made by the great masters for the purpose of practicing, and, in general, improving your skills.

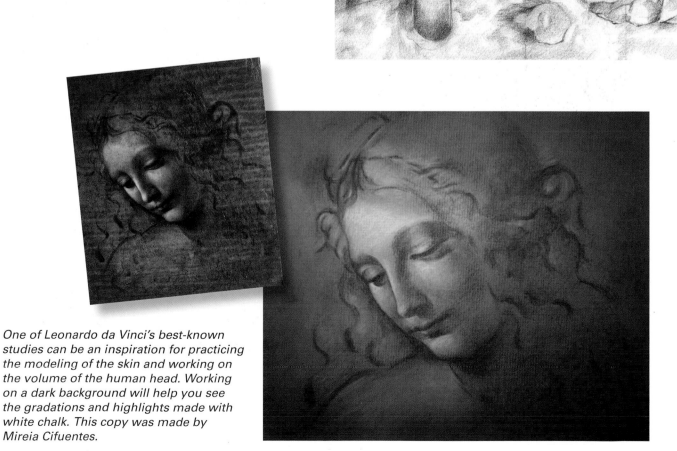

One of Leonardo da Vinci's best-known studies can be an inspiration for practicing the modeling of the skin and working on the volume of the human head. Working on a dark background will help you see the gradations and highlights made with white chalk. This copy was made by Mireia Cifuentes.

Matting
and Framing

When you finish the drawing, it is best to apply a spray fixative so that particles of pigment will not come off the support during or after the framing process. Not just any frame can be used for framing the copies. Choosing the form and color is more important than you would think for highlighting the final results of your work. It should be, preferably, of an antique look, with grooves and molding. The color does not have to be very fancy or bright, since the goal is to give the work an elegant air. Colors that are too bright will make the final result look brassy. We recommend using various colors for frames: white, honey, mahogany, and other earth tones, finished with glossy varnish and even with gold or silver leaf, like antique frames. You can purchase the frames in framing or craft stores, but you may also find them in secondhand stores and antique shops. There it is possible to find decorative wood frames and old-fashioned styles that will look like new after cleaning and adding glass.

This kind of artwork is normally mounted in a mat. The mat

If you wish to highlight a copy of an old drawing, you should look for a frame that complements the style. Frames with detailed moldings and finished with a gold or silver patina are always a good option.

When you are mounting two old 19th-century drawings, it is best to use varnished wood frames. In this case, simple molding and a wide mat helps emphasize the drawing.

Old frames like this one can be found in secondhand stores. They are usually sold for a reasonable price and will adapt well to the style of the drawings of the great masters.

consists of a piece of pressed cardboard with a rectangular window that not only keeps the glass from touching the drawing but also hides the edges of the drawing and creates a neutral area between the drawing and the frame. It is not usual for drawings to go all the way to the edge of the frame. The mat adds an elegant touch to the drawings and highlights their lines and shading. The work of art is usually attached to the mat with acid-free double-sided tape. The tape allows the work to be removed in the future without damaging the paper. Finally, on the back of the frame, either on the board or the top of the frame, hardware of different types is attached so the picture can be hung on the wall.

The mat is a small frame of pressed cardboard with a rectangular opening. It frames and highlights the work by separating it from the wood frame.

Drawings can be very delicate and should be preserved when finished by applying a thin layer of fixative from 6 to 8 inches (15 to 20 cm) away.

The main function of the mat is to hide the uneven and blurry edges. It is usually white or off white and creates a contrast with the colors of the drawing.

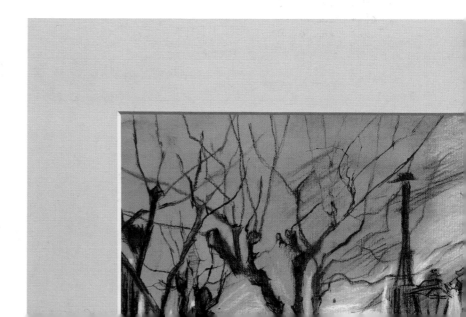

Original title of the book in Spanish:
Dibujar como los grandes maestros

Project and Publication:
Parramón Paidotribo

Managing Editor:
María Fernanda Canal

Editor:
Maricarmen Ramos

Text:
Gabriel Martín

Drawings:
Mireia Cifuentes, Merche Gaspar,
Gabriel Martín, and Teresa Seguí

Series Design:
Josep Guasch

Layout and Composition:
Estudi Guasch, S.L.

Photography:
Nos & soto

Multimedia Content:
BERLINƎST y Freeaudiolibrary
Books2ar

Production:
Sagrafic, S.L.

Prepress:
iScriptat

Translated from the Spanish by Michael Brunelle and Beatriz Cortabarria.

© Copyright 2016 Parramon Paidotribo – World Rights published
by Parramon Paidotribo, S.L., Badalona, Spain

First edition for the United States, its territories and dependencies, and Canada,
published 2017 by Barron's Educational Series, Inc.

English edition © 2017 by Barron's Educational Series, Inc.

All inquiries should be addressed to:
Barron's Educational Series, Inc.
250 Wireless Boulevard
Hauppauge, NY 11788
www.barronseduc.com

ISBN: 978-1-4380-0937-7

Library of Congress Control Number: 2016940643

Printed in China
9 8 7 6 5 4 3 2 1